THEN & NOW

SOUTH LAKE TAHOE

Opposite: Regan Beach is now home to a park, grass surfaces, and wooden deck areas. This historical view, made from the long wharf at Al Tahoe, includes Mount Tallac, Rubicon Peaks, and the shoreline of Lake Tahoe. El Dorado Beach is several hundred yards to the east. Shoreline views are quite common in the photographic history of Lake Tahoe. (Courtesy of Nevada Historical Society.)

THEN & NOW

SOUTH LAKE TAHOE

Peter Goin

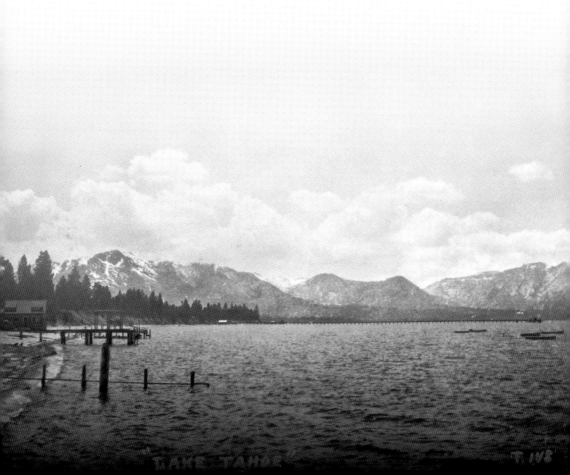

*This book is dedicated to all those photographers and researchers,
named and anonymous, who devote their talents to keeping Tahoe blue.*

Published by Arcadia Publishing
Charleston SC, Chicago IL, Portsmouth NH, San Francisco CA

Printed in the United States of America

For all general information contact Arcadia Publishing at:
Telephone 843-853-2070
Fax 843-853-0044
E-mail sales@arcadiapublishing.com
For customer service and orders:
Toll-Free 1-888-313-2665

Visit us on the Internet at www.arcadiapublishing.com

ON THE FRONT COVER: The road over Meyers Grade at Echo Summit is perennially undergoing road repairs. Historically, this route was a major thoroughfare from Sacramento and Placerville to Lake Tahoe and Carson City. Originally a toll road, this route was a major passageway for those who sought access to South Lake Tahoe, seen in the distance. (Courtesy of South Lake Tahoe Historical Society.)

ON THE BACK COVER: See page 78.

CONTENTS

ACKNOWLEDGMENTS

The support of four repositories was essential. Therefore, I am indebted to Betty Mitchell, South Lake Tahoe Historical Society; Lee Brumbaugh, Nevada Historical Society; Donnelyn Curtis, Special Collections, Mathewson-IGT Knowledge Center, University of Nevada; and Stefanie Givens, North Lake Tahoe Historical Society. Many people helped make this book possible, including those anonymous photographers whose visions help define Lake Tahoe. A few colleagues deserve special mention because of their good humor, gracious understanding, and unselfish assistance. Megan Berner was an invaluable research assistant and team leader who worked with the scanning, printing, and fieldwork. Scott Hinton, research associate, was always dependable, skilled, and helpful. Stephen Davis and Pamela Henning joined me on numerous horizon-finding missions. A few others assisted in finding sites, helping research local histories, and offering advice: Brig Ebright; Dana Goin; John Shilling; Rob Lober, accomplished pilot; and Kirk Pumphrey and his 1947 Chris-Craft wooden boat, *IV Phunn*.

This project had a life of its own. Michael Collopy, executive director of the Academy for the Environment at the University of Nevada, and Jerry Keir, executive director of the Great Basin Institute affiliated with the University of Nevada, invited me to become a mentor in the summer program, Research Experience for Undergraduates, sponsored by the National Science Foundation. The students in this program, Katie Gregory and Nicholas Liu-Sontag, worked throughout the summer of 2009 preparing images, searching sites, and developing caption data. Jamie Bernthal, Rebecca Carlson, and Jed Cohen participated for a day.

This book has both rarely published and recognizable popular images. Their collective importance is magnified once rephotographed from a site as close as possible to the original. Sometimes our team of rephotography experts could only estimate the location of a site. Some of the rephotographed views are different from the originals because we attempted to avoid trees, buildings, and signage. Lenses and cameras were markedly different in the historical era, and we used digital cameras with zoom lenses, hoping to capture the range of view as closely as possible. All rephotographs not specifically credited are by the author.

For further reading: Peter Goin's *Lake Tahoe* (Arcadia series), *Stopping Time: A Rephotographic Survey of Lake Tahoe*, and *Arid Waters*. Also check out L. B. Landauer's *The Mountain Sea: A History of Lake Tahoe*, Barbara Lekisch's *Tahoe Place Names*, E. B. Scott's *The Saga of Lake Tahoe* Vols. I and II, D. H. Strong's *Tahoe: An Environmental History*, and G. W. James's *Lake Tahoe: Lake of the Sky*.

INTRODUCTION

The explorer John Charles Frémont encountered Washo Indians in early February 1844, whereupon he was told of a spectacular body of water three- or four-days travel away. One of the Washo men drew a map, but he counseled Frémont against crossing the Sierra Nevada in the middle of winter. Frémont led his party south to what is now the Carson River, and disregarding the Washo's advice, he headed west into the mountains. The weather was severe, and Frémont's party suffered mightily as many of their animals perished in the biting cold and deep snow.

From the top of Red Lake Peak, now called Carson Pass, at the south end of the Tahoe Basin, Frémont made the first official sighting on February 14, 1844, of what is now Lake Tahoe. Frémont named the spectacular body of water Lake Bonpland after the French botanist Aimé Jacques Alexandre Bonpland (1772–1858). Bonpland was a companion of Alexander von Humboldt (1769–1859), a German naturalist, explorer, and statesman. This is the same Humboldt who is memorialized by the Humboldt River in Nevada and by two mountain ranges, the West Humboldt in northwestern Nevada and the East Humboldt in northeastern Nevada. Frémont's report, published in 1845, narrates his discovery as "a beautiful view of a mountain lake at our feet." Thus begins a confusing legacy over the naming of the lake, as the preceding passage is credited as the source by which early cartographers identified Lake Bonpland as "Mountain Lake."

However, by 1857, the lake had been renamed Lake Bigler after California governor John Bigler, who served from 1852 to 1856. During the Civil War, numerous Union sympathizers objected to naming the lake after the governor, an outspoken secessionist proponent. During the subsequent renaming efforts, a few unusual suggestions were proffered, including "Lake Union," a direct response to Bigler's unpopular beliefs. Dr. Henry De Groot, an explorer and journalist, was charged to come up with a new name, and he suggested Tahoe. Maps from 1862 list Lake Tahoe as the Sierra jewel's namesake, but that name was not official until the California State Legislature enacted a law in 1945. The origin of the name Tahoe is unclear, although Frémont recorded two Washo words, "*Tah-ve*," identifying snow, and "*Mélo*," signifying friend. In 1859, Indian agent Maj. Frederick Dodge recorded "*Ta-hou*" to roughly mean "big water." The precise etymological origins of the word "Tahoe" may never be known, but its lyrical title endorses its permanence.

Lake Tahoe's geomorphology is more determinable. Lake Tahoe is the North American continent's largest alpine lake—22 miles long, 12 miles wide, and covering a surface area of 191.6 square miles with 72 miles of shoreline. Lake Tahoe is shared between both California and Nevada, although the split is two-thirds in California and one-third in Nevada. The lake's surface is 6,226 feet above sea level, and the natural rim is 6,223 feet above sea level, making it the highest lake of its size in the United States. Lake Tahoe is the third deepest lake in North America and the 10th deepest in the world. Tahoe's deepest point is 1,645 feet, near Crystal Bay; the average depth is 989 feet. The geological structure of the basin was

formed during the last ice age. Glaciers carved Emerald Bay, Fallen Leaf Lake, and Cascade Lake. Mount Tallac is 9,735 feet, the highest peak rising from the shoreline. At the time of development, the Tahoe Basin was rich in natural resources, from sweet water and native fisheries, to plentiful stands of Jeffrey pine, white fir, quaking aspen, and ponderosa pine. What captured the imagination of distant observers, however, was the potential for finding gold.

Not until the early 1850s did rancher John Calhoun Johnson pioneer a route across Johnson (currently Echo) Pass, connecting Placerville and the Carson Valley. This trail opened the south end of the Tahoe Basin, named Lake Valley. The discovery of the Comstock in 1859 transformed the Tahoe Basin because this mining boom attracted thousands of people from California to the Nevada Territory. The first west-to-east toll road, the "Bonanza Road," was completed in 1863, facilitating a steady flow of heavily loaded wagons hauling mining machinery, firewood, food, tools, and household items over Johnson Pass on the way past Lake Tahoe to the mines near Virginia City.

Nearly every community at Lake Tahoe owes its origin to a resort or hotel. Unfortunately none of these historic inns have survived into the modern era. Most were destroyed by fire, a common problem. Steamship travel came of age at Lake Tahoe in 1872, but the heyday was short-lived. By the mid-1870s, roadways had been completed across the rugged shores of Emerald Bay and around the northeast corner of the lake, completing a circuit around Lake Tahoe. The age of the automobile in the Tahoe Basin was soon to follow. Farms and ranches appeared along the perimeter of the lake wherever hay could be grown and livestock grazed. Meeks Bay, on the west side of the lake, became an important collection point for timber heading to Glenbrook. More than 70 million board feet of lumber came from Lake Tahoe during the peak years.

Unfortunately, in its wake, the lumber industry left a drastically altered landscape. Most of the old-growth forest was gone, replaced by open hillsides littered with slash-and-sawdust-choked creeks and rivers. At the south shore, logging camps, mills, flumes, and railroads lay abandoned. Acreage sold cheaply because the land was thought to have little value. The Tahoe Basin entered a period of decline, and fire danger increased. In 1898, a fire started near Meyers and consumed everything in its eastern path. Four years later, a U.S. forest agent reported many smoldering fires throughout the California side of the lake. In 1903, a fire near Bijou burned unchecked for more than three weeks. From the beginning of the 19th century to the 20th century, Lake Tahoe was not perceived as a rich resource suitable for exploitation. Future development, including urbanization, depended on revitalizing tourism.

The Sierra Club campaigned as early as 1896 for a national park at Lake Tahoe. In 1900, the Bliss family offered their extensively logged Tahoe acreage, but public distrust prevailed. The federal government created a Lake Tahoe Forest Reserve southwest of the lake in 1899, which was joined later by other forestlands purchased in the public trust. Nevada legalized gaming in 1931, creating a two-culture style of life at Lake Tahoe. As the years passed and the memories of rampant exploitation waned, visitors remarked on the scenic beauty, cathedrals of granite, second- and-third-growth forests, crystal clear waters, boating, hiking, excellent skiing, and support communities for the gaming industry. In 1965, seeking relief from rampant, unplanned development, voters from Al Tahoe, Bijou, Stateline, and Tahoe Valley created the incorporated city of South Lake Tahoe. Its post office opened on March 24, 1967. Today the resilient essence of South Lake Tahoe, from its brisk mountain air to the profound clarity of its deep waters, is a cornerstone of an evolving tourist economy. As the photographic pairs demonstrate, South Lake Tahoe is inalterably changing yet conforming as much as possible to the landscape that early poets, visionaries, and health-seekers envisioned.

CHAPTER 1

SOUTH LAKE TAHOE

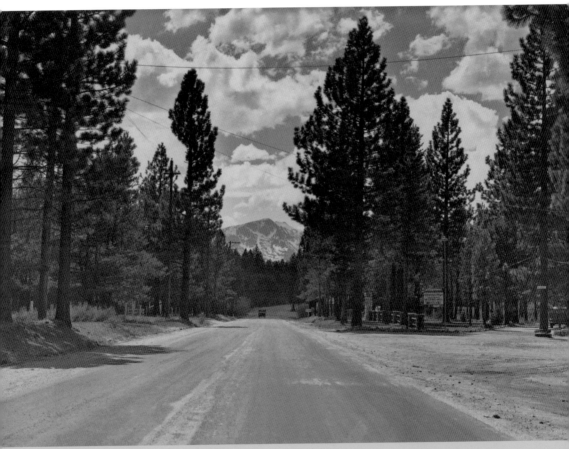

Mount Tallac, the sentinel symbol of South Lake Tahoe, was previously rephotographed by the author in *Stopping Time: A Rephotographic Survey of Lake Tahoe*. This is Highway 50 next to Lakeland Village. The visitor's first experience of Lake Tahoe evolved from steamer traffic to the modern face of South Lake Tahoe; one principally suited for automobile tourists. (Courtesy of Special Collections, University of Nevada, Reno.)

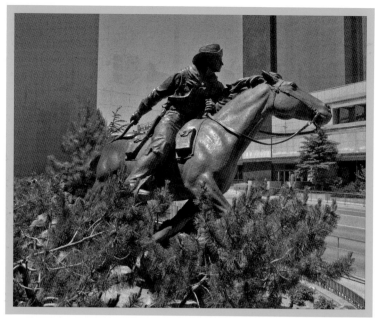

Shortly before midnight on April 28, 1860, the first Pony Express rider to cross the Sierra via Kingsbury Grade was on his way east. Started by a Missouri freight firm called the Pony Express, the horses and their riders carried letters and telegrams from 1860 to 1861 on the central route from San Francisco to St. Joseph. This statue commemorating the event, unveiled on April 4, 1963, was originally facing in a southerly direction; however, today it points northwest. (Courtesy of Nevada Historical Society.)

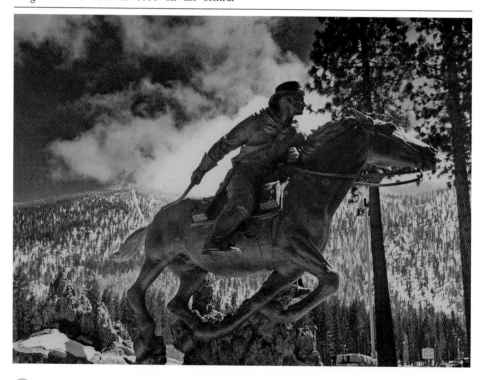

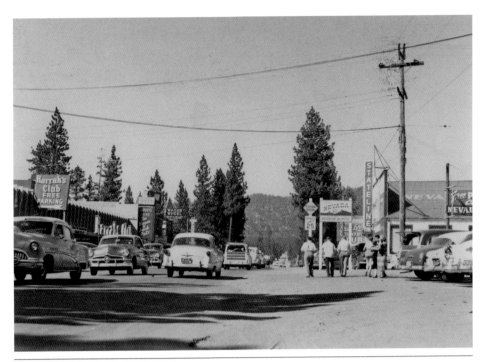

This view of Stateline, Nevada, taken around 1956, pictures Harrah's Club, the Wagon Wheel, and the Stateline Country Club. Pioneers in the Stateline gaming business include Clyde Beecher, George Cannon, Harvey Gross, and William F. Harrah. The transformation of a modest entertainment economy into a major economic engine began when gaming was legalized by the Nevada legislature in 1931. Gambling establishments are illegal in California, creating essentially a two-culture way of life in the Tahoe Basin. (Courtesy of Nevada Historical Society.)

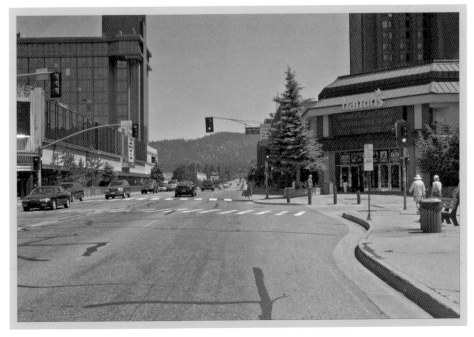

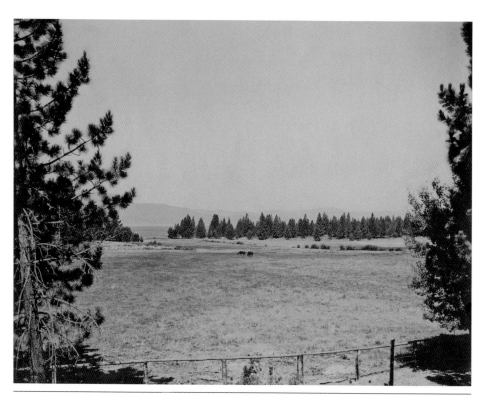

Cattle grazing has always been a part of the Tahoe landscape, especially within the southern, eastern, and western meadows. This site, near Stateline, was originally fenced grazing pasture, but it has now become a recreational landscape recognized as the Edgewood Tahoe Golf Course. This course was designed by the well-known golf-course architect George Fazio and is the home of the American Century Celebrity Golf Championship and plays host to the U.S. Senior Open and U.S. Public Links. (Courtesy of South Lake Tahoe Historical Society; Scott Hinton rephotograph.)

According to the original caption for the image below, "Indigenous crops grew fantastically in the fertile soil and rarefied air. Here, northwest of Hobart, oxen are pulling a wheel plow in the summer of 1892." The Chris Rabe family farmed this land and occasionally provided lodging for those passing through on their way to Carson City. The contemporary view is near the fairway for the first hole of the Edgewood Tahoe Golf Course. (Courtesy of Nevada Historical Society; Scott Hinton rephotograph.)

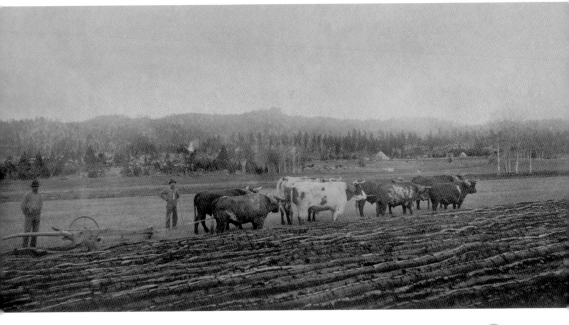

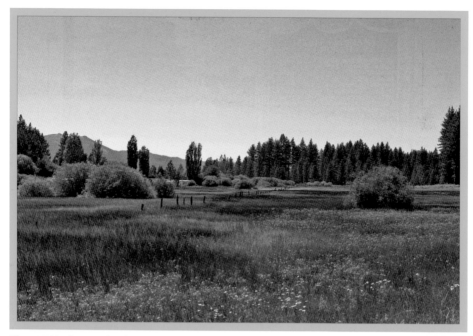

The 1933 historical photograph incorrectly identifies this view as the South Lake Tahoe Airport. While arguably the precursor to the South Lake Tahoe Airport, the site of the photograph below is near the boardwalk that spans a marsh close to the lake at Stateline. The first land-based airplane to touch down and take off in the basin was in 1933 on the grounds that would be the site of Harvey's Wagon Wheel. (Courtesy of Nevada Historical Society; Scott Hinton rephotograph.)

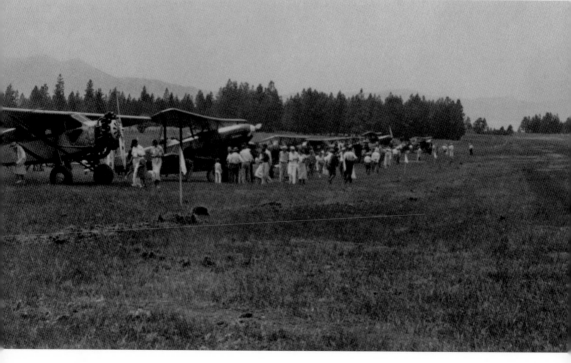

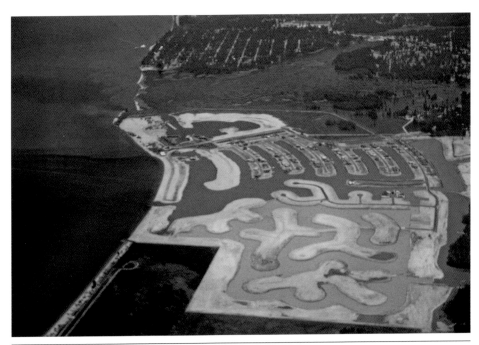

The historical photograph of the Tahoe Keys was made around 1958 when the area was developed as a unique boater's paradise. The image is part of an archive from the Lake Tahoe Area Council, a private, nonpolitical, nonprofit organization. This group was dedicated to solving basin-wide problems of planning, land use, park and recreational development, pollution control, and soil conservation. The council was disbanded in 1975 due to lack of operating funds. (Courtesy of Special Collections, University of Nevada, Reno.)

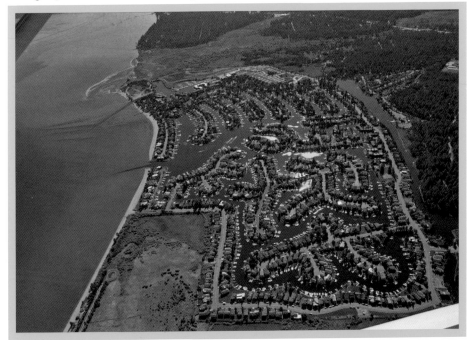

The Tahoe Keys were built in the late 1950s as a popular area for recreational living. Unfortunately its development has led to several environmental problems. Landfill forever altered a large filtering marsh leading to more fine-particle sediment, lowering the clarity of the lake; also, Eurasian water milfoil, an invasive aquatic plant, has developed a strong hold in the area, resisting efforts by water authorities to eradicate it. (Courtesy of Special Collections, University of Nevada, Reno.)

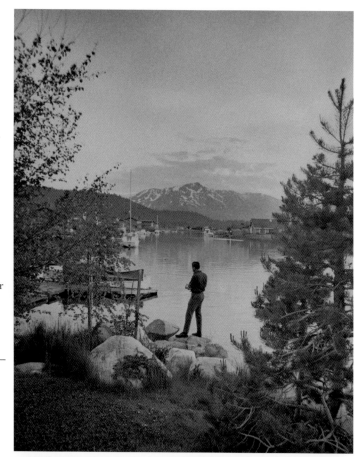

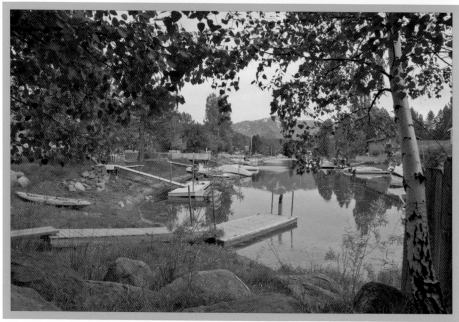

Tahoe Paradise is a subdivision east of Angora Lakes and El Dorado National Forest divided by North Upper Truckee Road. Tahoe Paradise is in a high–fire danger zone and adjoins Washoe Meadows State Park. The contemporary view was photographed from the road looking across the side yard of 1233 Dixie Mountain Drive; the view is not exactly the same, but close: the trees and landscaping completely obstruct the historical view. (Courtesy of Special Collections, University of Nevada, Reno; Scott Hinton rephotograph.)

Large-scale housing development transforms Lake Tahoe and elsewhere. The Tahoe Paradise subdivision is located on relatively level ground bounded on the west by the Echo Summit ridge and on the east by the Upper Truckee River. This contemporary view of the main road artery (above), just beyond Shoshone Street, points downhill from North Upper Truckee Road. The 2007 Angora Fire destroyed 254 homes and burned 3,100 acres. (Courtesy of Special Collections, University of Nevada, Reno; Scott Hinton rephotograph.)

CHAPTER 2

HISTORIC BUILDINGS, ESTATES, RESORTS, AND ROADWAYS

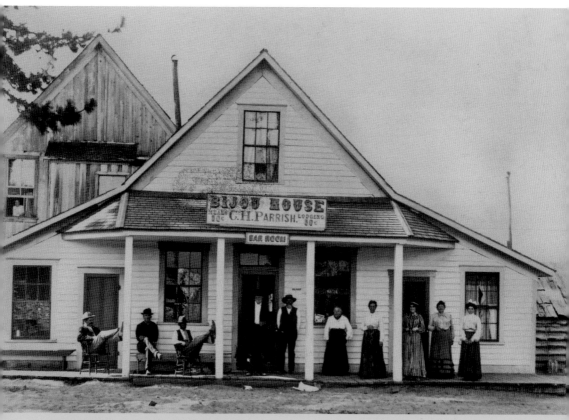

The Bijou House, located behind what is now the Bijou Center (CVS/pharmacy), was Young's Bijou Lodge during the 1920s and 1930s. Charles H. Parrish, a wealthy and prominent early innkeeper, purchased Bijou Pier in 1886 and built a rambling, one-story house with a saloon and a dance floor. According to tax records, Parrish was principally known for making and selling his own whiskey. (Courtesy of Nevada Historical Society.)

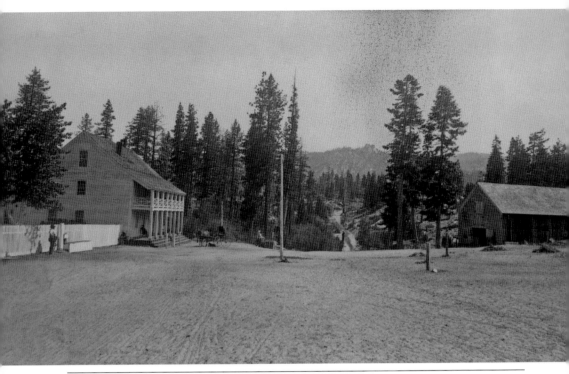

In 1860, a new toll road over Daggett Pass opened, requiring a new station for the Pony Express. Friday's Station was used. This 320-acre site was first owned by Martin K. "Friday" Burke and John Washington Small. Friday's Station was known as the last "mountain oasis for travelers going east" according to E. B. Scott's *The Saga of Lake Tahoe*. The exterior has been modified but still bears remnants of the original structure's appearance. (Courtesy of Nevada Historical Society; Scott Hinton rephotograph.)

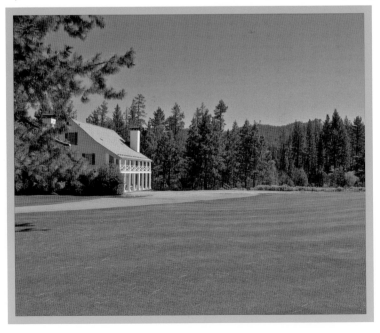

HISTORIC BUILDINGS, ESTATES, RESORTS, AND ROADWAYS

Lakeside Park (House) was purchased and rebuilt by E. B. "Starvation" Smith in 1892. Posing below in the summer of 1896 are Mr. and Mrs. E. B. Smith in the front seat of a buggy; in the hay wagon are Mattie Hobe, Laura and Ed McFaul, the Heiberts, Joe Haul, and Ed McFaul. This spectacular barn was originally part of the old Lapham's Station. No remaining landmarks indicate the precise location of the barn. (Courtesy of Nevada Historical Society; historical photograph by Arthur M. Hill; Scott Hinton rephotograph.)

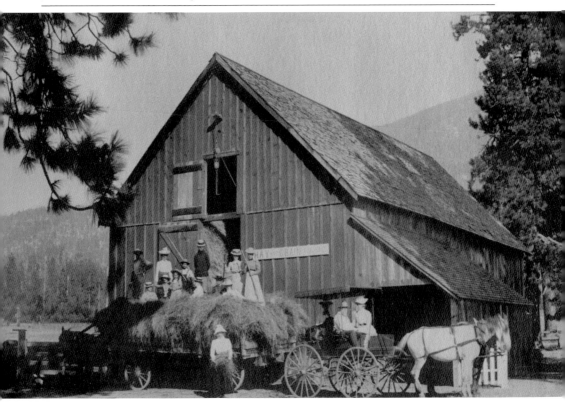

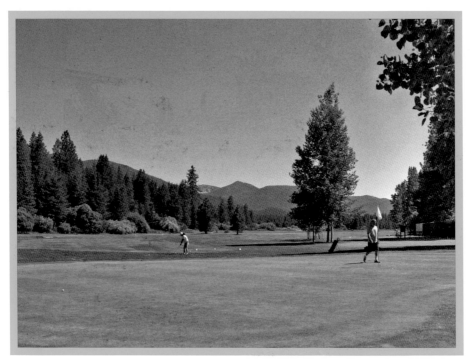

Almon M. Taylor homesteaded a 160-acre ranch near this location in Lake Tahoe's early days. While highly suitable for ranching, the homestead evolved into a lumbering operation and had its name changed from Taylor's Landing to Bijou. Today the site is the Bijou Golf Course. Bijou Park Camping Grounds (1920) might have served guests at the Bijou Inn on Lakeshore Drive. (Courtesy of South Lake Tahoe Historical Society; Scott Hinton rephotograph.)

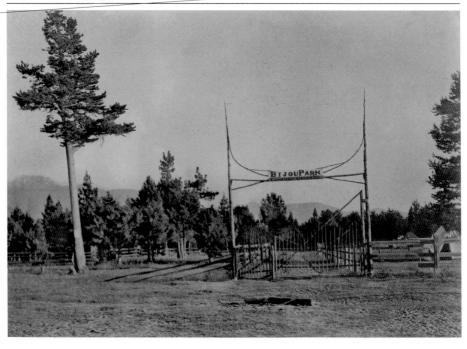

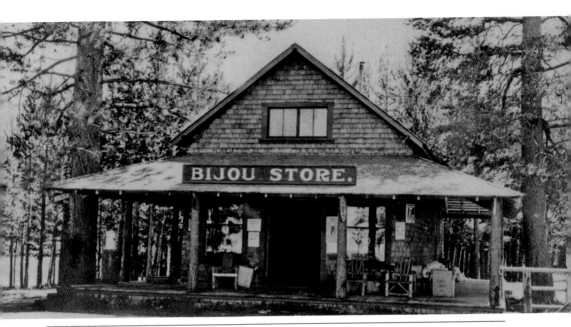

The Bijou Store (photograph *c.* 1919) was located along Bal Bijou road behind what is now the Bijou Center (CVS/pharmacy). During the 1920s and 1930s, the store was known as Young's Bijou Lodge. The house is now a private residence. It has been remodeled, and the front entrance has been moved to the west side of the house. At one time, Bijou had a thriving recreational identity boasting the largest dance pavilion on the lake. (Courtesy of Nevada Historical Society.)

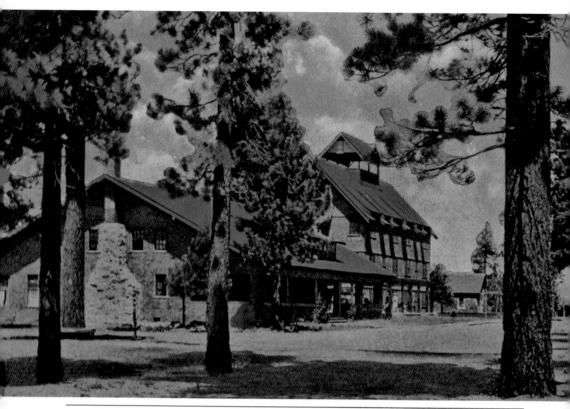

The community of Al Tahoe is the site of Lake Tahoe's first lakeshore hotel, the Lake House (which burned in 1866). Al Tahoe officially entered Lake Tahoe history in 1907 when Almerin "Al" Sprague built the original Al Tahoe Hotel. He combined his nickname with Tahoe to produce the final name. The post office for Al Tahoe was established on August 11, 1908, and Sprague became its first postmaster. The resort no longer exists. (Courtesy of Nevada Historical Society.)

HISTORIC BUILDINGS, ESTATES, RESORTS, AND ROADWAYS

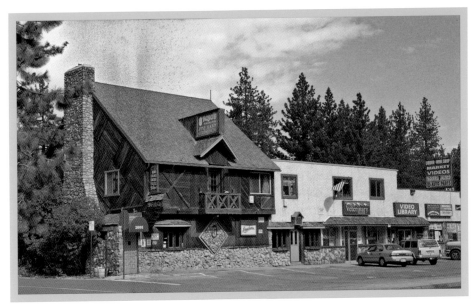

In 1924, Frank Globin purchased the Al Tahoe Hotel, including the casino, cottages, and cabins, and operated it with his wife for nearly 35 years. The establishment was severely damaged by fire in the spring of 1956, although the chimney remains intact. In 1975, Rodger Wright and Joe Hansen purchased the business and reopened it as Rojo's, a bar and restaurant reflecting its original rustic Tahoe ambiance. (Courtesy of South Lake Tahoe Historical Society.)

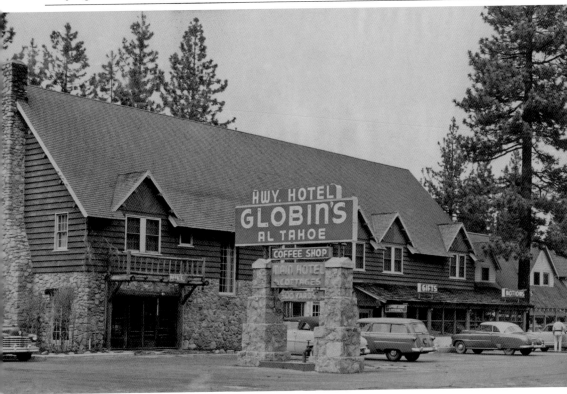

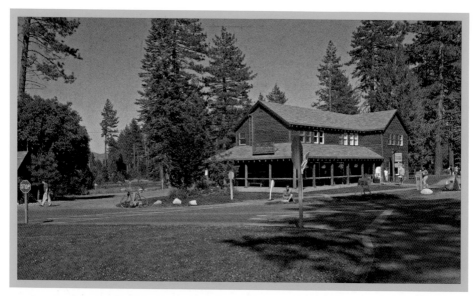

In 1921, Alonzo LeRoy Richardson leased the land from its owners and built a small stage station on the main road, now Highway 89. Camp Richardson's history chronicles logging operations, a railroad, financial ruin, and one of the largest recreational areas in South Lake Tahoe. Today, Camp Richardson includes summer cabins, a pier, tent camping, horseback riding, and more. Also called "the Grove," the site is now owned by the U.S. Forest Service. (Courtesy of South Lake Tahoe Historical Society.)

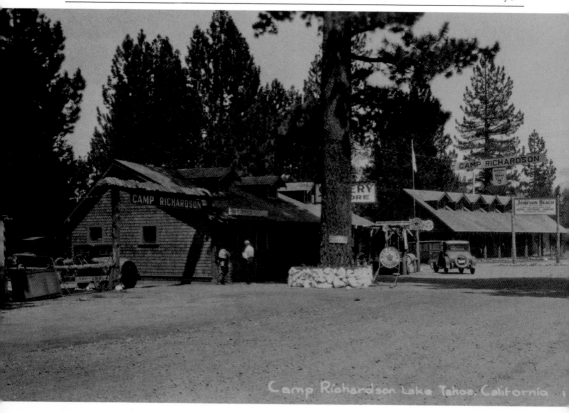

HISTORIC BUILDINGS, ESTATES, RESORTS, AND ROADWAYS

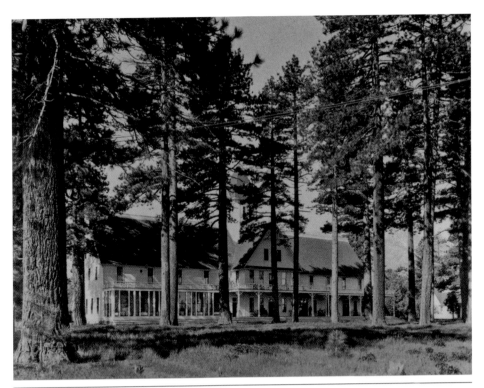

Ephraim "Yank" Clement built this 40-room hotel in 1875. In the summer of 1881, Yank's Hotel became Elias Jackson "Lucky" Baldwin's Tallac Hotel. Now a historical site, Tallac had a store, a livery, several barns, a saloon, a casino, and a dance floor mounted on springs. Because of Baldwin's protective measures, the site contains some of the last remaining virgin timber bordering Lake Tahoe. The Tallac Hotel was known as one of the premier recreational sites in the United States. (Courtesy of Nevada Historical Society.)

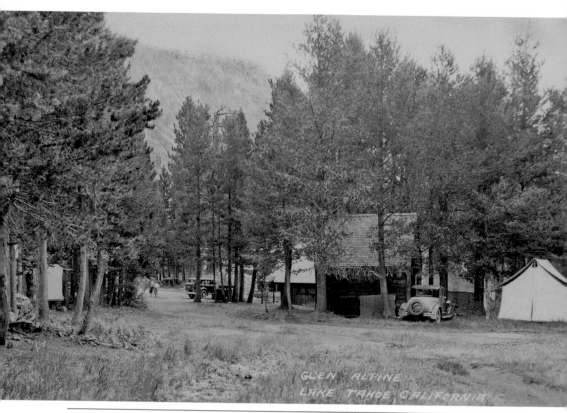

Nathan Gilmore, a young rancher from Ohio, discovered springs in the high country above Fallen Leaf Lake in 1863. Gilmore moved his family to the site, whereupon his wife, Amanda, recalling a passage in Sir Walter Scott's *Lady of the Lake*, named it Glen Alpine Springs. Gilmore built a cabin and eventually bottled Glen Alpine Tonic Water, which became famous throughout California and Nevada. Eventually Glen Alpine Springs became a thriving resort. (Courtesy of Special Collections, University of Nevada, Reno.)

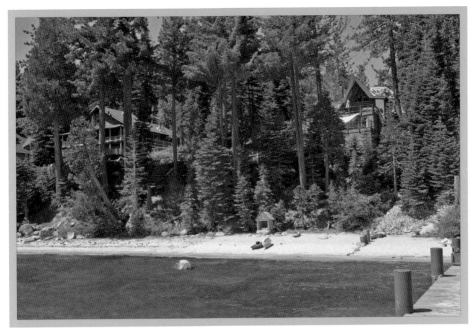

Early in the 20th century, the George Newhall family purchased 273 acres on Rubicon Bay where they constructed a three-and-a-half-story mansion with a boathouse and a pier. By 1926, they had 350 acres, but by 1935, the land was sold to Fred Kilner and the Williams family, who tore the home down in 1949. At that point, the estate became a subdivision with summer homes flanking the eastern end of Lonely Gulch. (Courtesy of North Lake Tahoe Historical Society.)

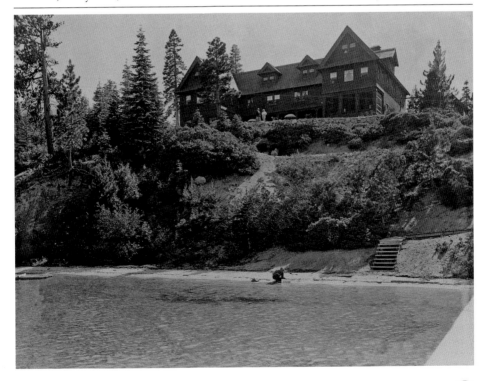

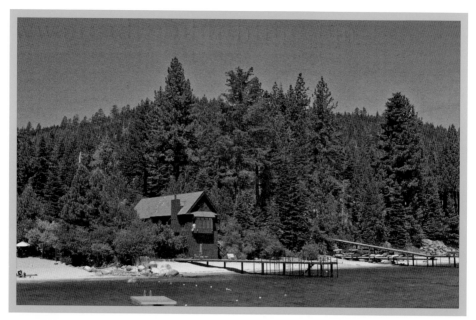

This boathouse from the original Rubicon Lodge survives to this day. The Rubicon Lodge's heyday was from approximately 1900 to 1915, when it was divided into numerous tracts, including acreage that the Newhall family acquired. The succession of land ownership is complex, but this boathouse has survived and endured numerous reiterations. The original Newhall home was torn down in 1949. (Courtesy of Special Collections, University of Nevada, Reno.)

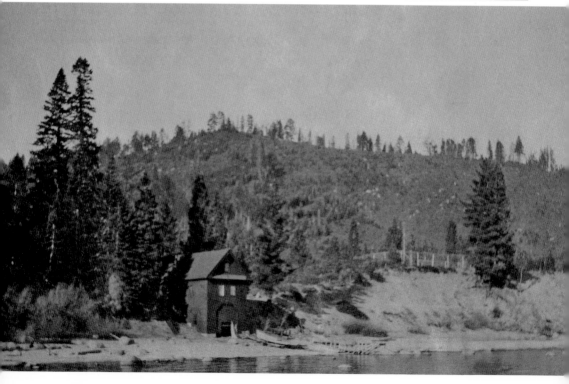

HISTORIC BUILDINGS, ESTATES, RESORTS, AND ROADWAYS

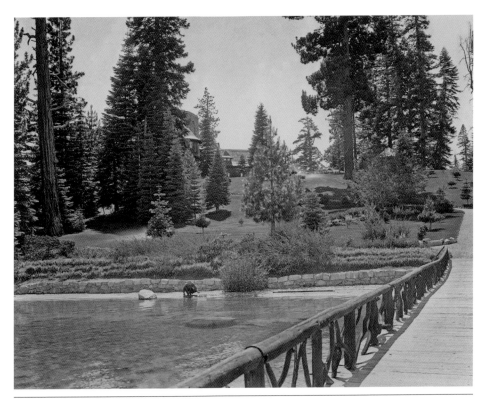

In the late 1800s, banker Isaias Hellman visited Lake Tahoe on a business trip. The forested mountains reminded him of his native Bavaria, so Hellman purchased property on the promontory now known as Sugar Pine Point. Walter Bliss designed a three-story, shingle-style California craftsman summer home. It was completed in 1903 and was named Pine Lodge. In 1965, Pine Lodge and its estate was sold to the State of California and became Sugar Pine Point State Park. (Courtesy of North Lake Tahoe Historical Society.)

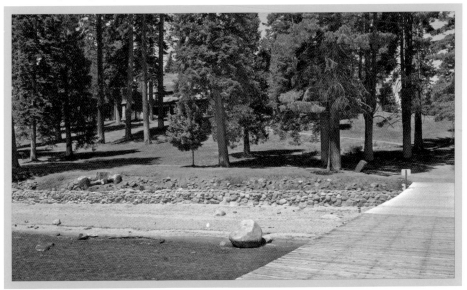

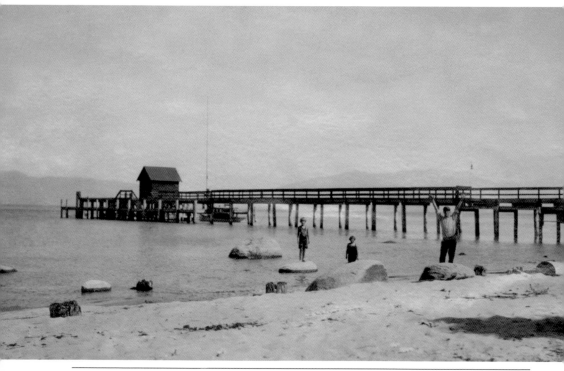

The original Pine Lodge estate consisted of the summer mansion, a boathouse, and a pier. Isaias Hellman's youngest daughter, Florence, inherited the home and later married Sidney Ehrman, who kept up the summer traditions of Pine Lodge. The lodge was subsequently renamed the Ehrman Mansion. The pier was rebuilt immediately next to the site of the original pier, which was destroyed by fire. (Courtesy of Special Collections, University of Nevada, Reno.)

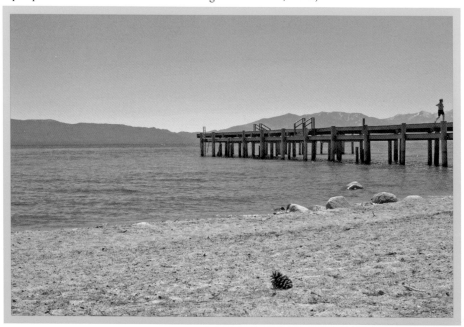

HISTORIC BUILDINGS, ESTATES, RESORTS, AND ROADWAYS

EMERALD BAY

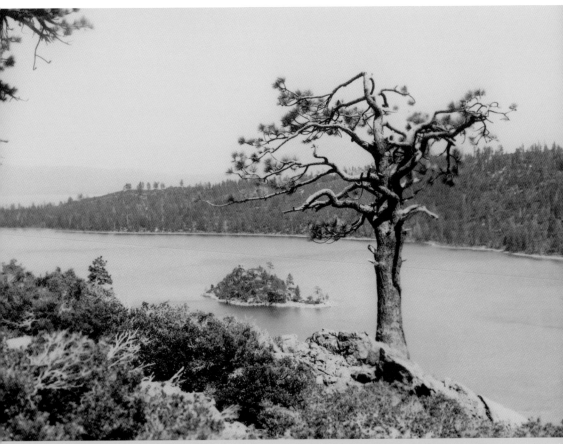

This elderly statesman at the rocky edge of the promontory guards the view of Emerald Bay. By 1954, California had acquired significant lands around Emerald Bay and contiguous to D. L. Bliss State Park, creating Emerald Bay State Park. During 1964, representatives from the Sierra Club, Friends of Emerald Bay State Park, and Save the West Shore of Lake Tahoe successfully opposed a west shore freeway and a bridge across Emerald Bay. (Courtesy of Special Collections, University of Nevada, Reno.)

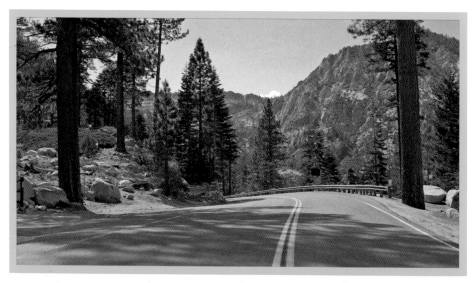

One of the most difficult highway projects in the Tahoe Basin circumnavigated Emerald Bay. Once the roadway was completed, auto-based visitors flocked to the panoramic promontory Inspiration Point and Mrs. L. N. Kirby's Bay View Resort, which was hidden amongst the trees at left. The resort hotel had a large parlor and dining room, and was surrounded by little guest cottages. Boats and fishing tackle were free for guests. The resort no longer exists. (Courtesy of Special Collections, University of Nevada, Reno.)

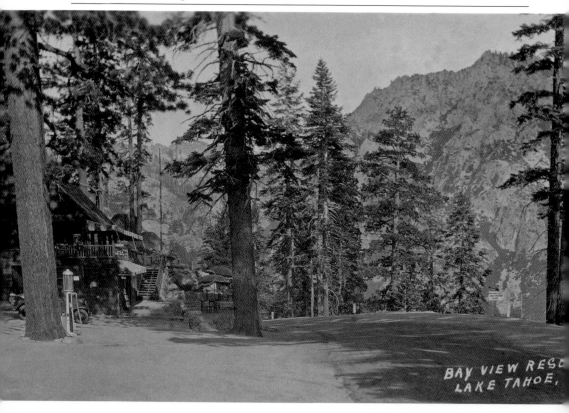

BAY VIEW RESC
LAKE TAHOE,

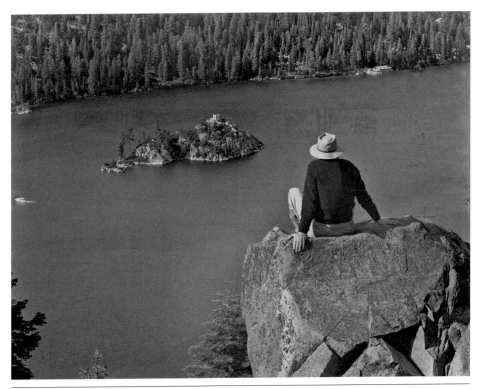

At the southernmost edge of Inspiration Point, the roadway opens up, revealing partial views of Emerald Bay. The second- and third-growth forests have obscured the view evident in the historical photograph. Nick Liu-Sontag, a research assistant, poses to duplicate the viewing strategy. Fannette Island, visible in the historical photograph, was originally Lora Knight's teahouse, an extension of her estate, Vikingsholm. (Courtesy of Special Collections, University of Nevada, Reno.)

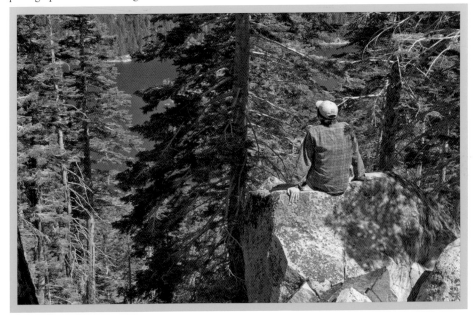

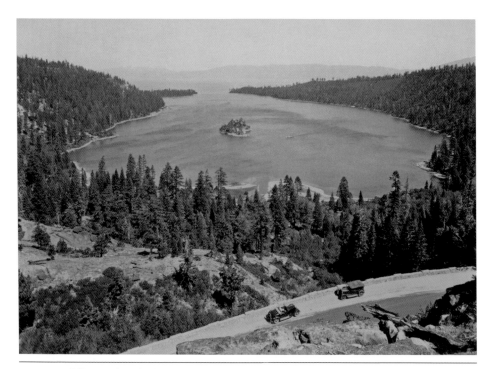

A granite cliff rises directly above the roadway, providing a spectacular view of the rock-constructed road and Emerald Bay. Nestled at lake level at the outlet of Eagle Creek is the site of Lora Knight's Scandinavian-themed estate, Vikingsholm. Emerald Bay's status as a tourist magnet is reinforced by spectacular scenery and by exotic stories about Capt. Dick Barter, an eccentric hermit and Emerald Isle caretaker who drowned while inebriated in 1873. Emerald Bay is a perennial favorite destination for boaters of all kinds. (Courtesy of South Lake Tahoe Historical Society.)

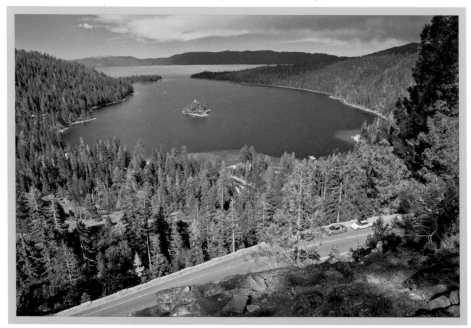

During the early settlement days of Lake Tahoe, most of the views of the landscape were made from the water because roadways were not yet developed or completed. In this view below, Lake Tahoe is beyond the mouth of Emerald Bay. To this day, boaters will inevitably make the pilgrimage to the horseshoe-shaped bay, viewing Fannette Island, visiting Lora Knight's Vikingsholm, or boat camping along the west shore. (Courtesy of Special Collections, University of Nevada, Reno.)

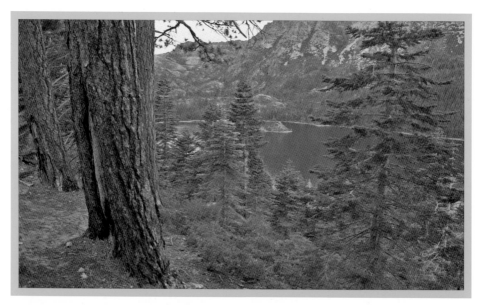

Emerald Bay is the quintessential visual identifier of Lake Tahoe. Numerous photographs from all angles and altitudes have been made throughout the past 100 years. The historical view below is from a hidden picnic area above the lake on the east side near Eagle Point Campground. Fannette Island is closed to visitors from February 1 through June 15, and swimming to the island is prohibited. (Courtesy of Special Collections, University of Nevada, Reno.)

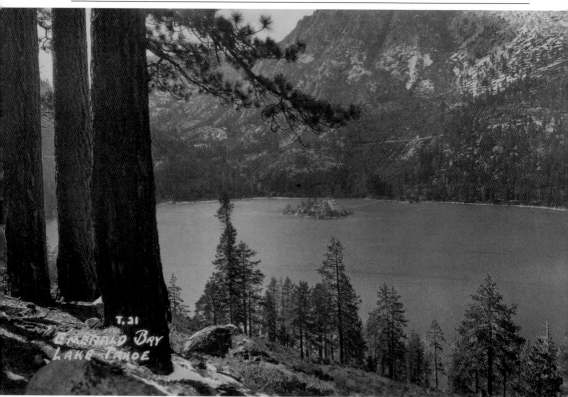

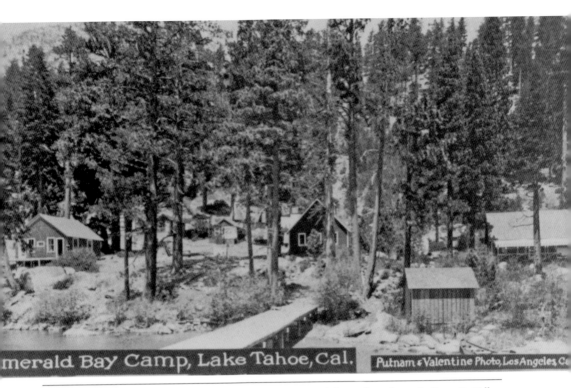

merald Bay Camp, Lake Tahoe, Cal. Putnam & Valentine Photo, Los Angeles Ca

Emerald Bay Camp was one of the most highly rated resorts in all of Lake Tahoe. The camp was nestled among the stately pines of the north side of the bay and consisted of a relatively modest hotel, cottages, and tents. Nelson L. Salter, a recognized figure throughout the Yosemite Valley, purchased Emerald Bay Camp in 1914. Salter sold the property to the parks division of the State of California in 1947. (Courtesy of South Lake Tahoe Historical Society.)

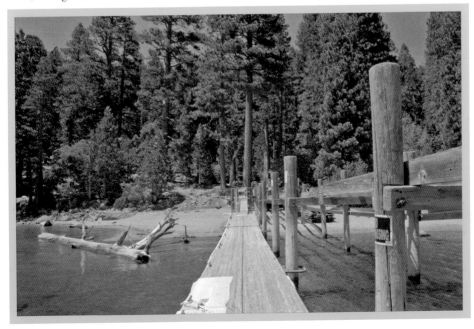

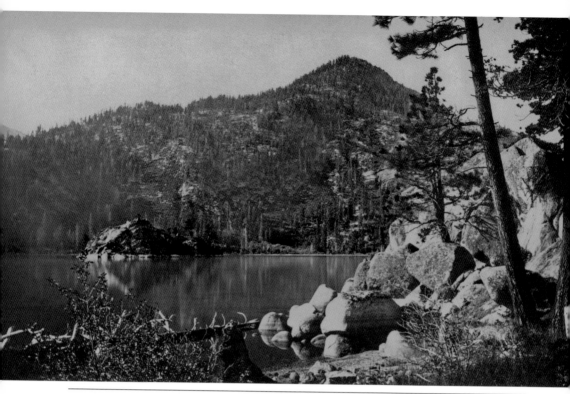

This is a view of Fannette Island, and to the right is Parson's Rock. This site was a favorite for alpine religious services, hence the name. The historical photograph predates the construction of Lora Knight's teahouse, which was erected in 1928–1929. R. J. Waters, a prominent Lake Tahoe photographer during the 19th century, made the historical photograph. Highway 89, visible in the contemporary view, was constructed in 1930–1931, and the rock slide occurred on Christmas day 1955. (Courtesy of Nevada Historical Society.)

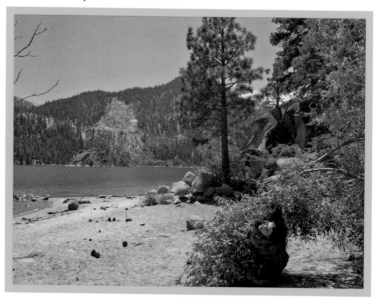

Indian Camp at Emerald Bay is the movie set for *Rose Marie*, starring Jeanette MacDonald and Nelson Eddy. The set at Lake Tahoe was a stand-in for western Canada. The plot of the film has a woman fall in love with a trapper, who is pursued by a Canadian Mountie, who, in turn, is pursued by the amorous daughter of a local tribal chieftain. Totem poles from the movie decorate private residences along the west shore. (Courtesy of North Lake Tahoe Historical Society; Scott Hinton rephotograph.)

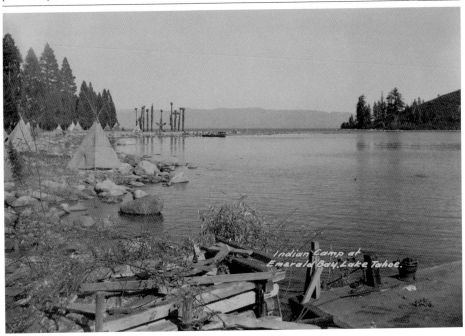

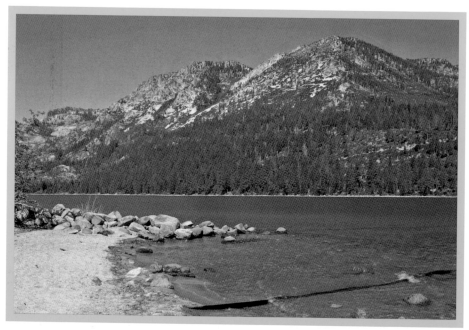

R. J. Waters, purser aboard the steamer *Tod Goodwin,* and a veteran Tahoe photographer, made this historical image between 1867 and 1880. There is not that much evidence of landscape change except the lake level is lower now than then. Additionally, the shoreline reveals a water pipe. The Eagle Point Campground is located at Eagle Point above the ridgeline behind the shore. A barge-wreck dive site is near the shore to the south. (Courtesy of North Lake Tahoe Historical Society.)

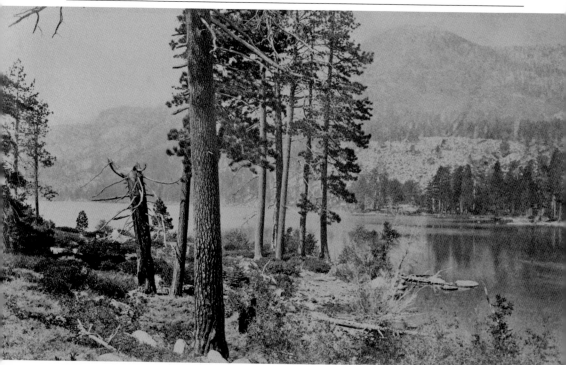

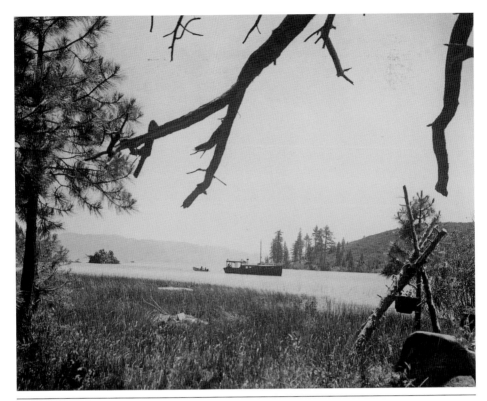

San Francisco's Potter School Camp for Boys opened in 1918 on the northwest point of Emerald Bay. Charles Bradley, the school's principal, had a residence on land provided by Walter Danforth Bliss. The historical photograph was taken south of Bradley's house. The launch *Mount Rose* is anchored at center. The iron kettle and tripod for cooking are left to history. Also the trees on a spit of land are no longer there. (Courtesy of North Lake Tahoe Historical Society; Scott Hinton rephotograph.)

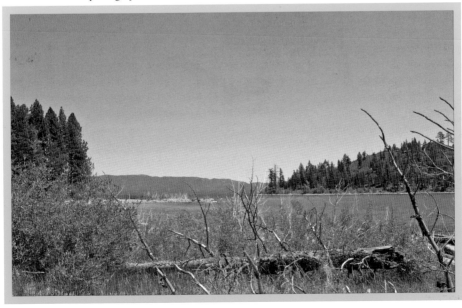

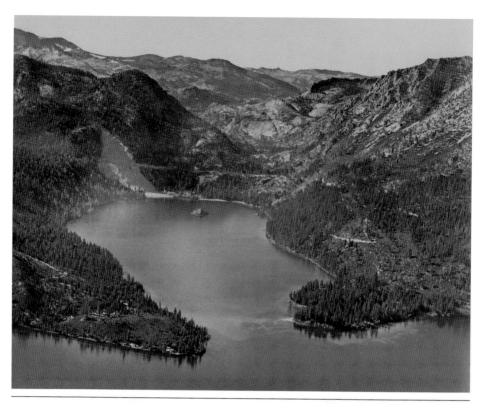

Whether from land, lake, or air, Emerald Bay is one of Lake Tahoe's most unique environments. The name Emerald Bay first appeared on the Hoffmann topographical map of 1873. During extremely cold winters, Emerald Bay will freeze, creating a gem of color and spectacle. The bay is slightly less than 3 miles long and approximately two-thirds of a mile wide. (Courtesy of Special Collections, University of Nevada, Reno.)

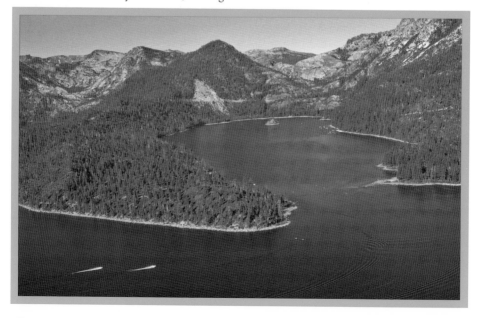

4

SHORELINES FROM
STATELINE TO
HOMEWOOD

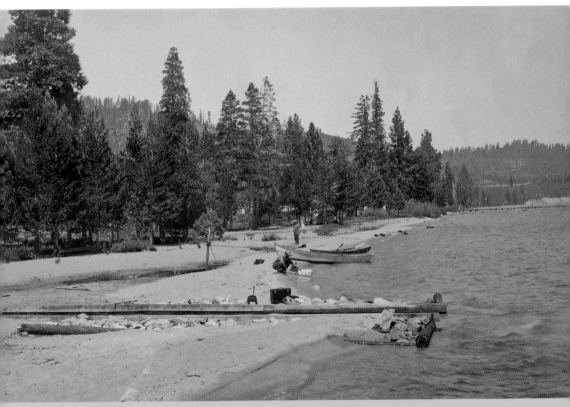

This photograph, made from the shore end of the wharf at Rubicon Park Camp, is part of a large project called the 1916 Tahoe Shoreline Survey. The photographer was Herford T. Cowling of the U.S. Reclamation Service, and D. S. Stover was the assistant engineer who made the field notes. The project documented shoreline lake levels, and the visual record circumnavigates Lake Tahoe. Numerous photographs from this survey have been reproduced herein. (Courtesy of Special Collections, University of Nevada, Reno.)

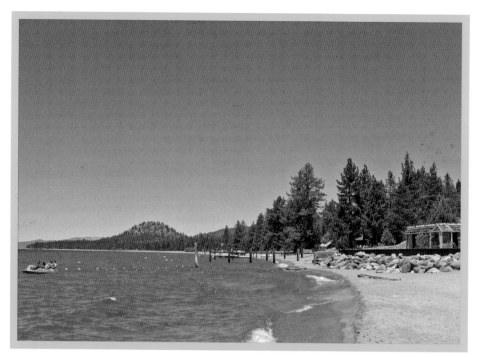

A prominent landmark along the east shore of Lake Tahoe is Little Round Top Mountain. Also pictured is Hobart Landing across from the Royal Valhalla, which has a private, protected beach in front of the hotel. Round Hill was also known as Folsom's Knob and Peak. This area was heavily logged around 1893, indicating its industrial, extractive origins. (Courtesy of Nevada Historical Society; historical photograph 1900 by A. M. Hill; Scott Hinton rephotograph.)

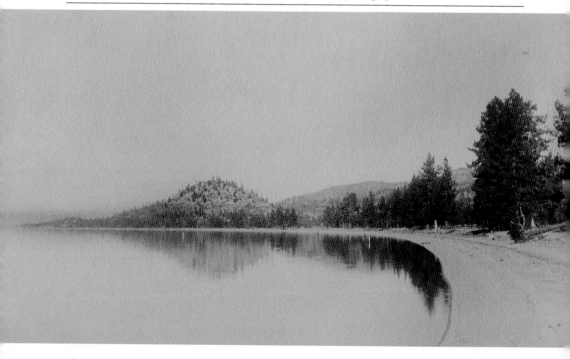

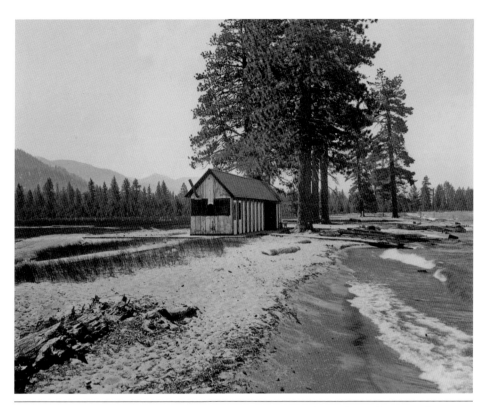

The historical photograph was taken looking southeast from the shore end of the wharf at Lakeside, California. Approximately 50 feet from the shore to the south of the bathhouse lay the Nevada state line monument. The California-Nevada boundary line has been resurveyed at least four times, ultimately resulting in gifting more than 27 square miles of land and lake to California. Some writers argue that the miscalculation was deliberate. (Courtesy of North Lake Tahoe Historical Society; Scott Hinton rephotograph.)

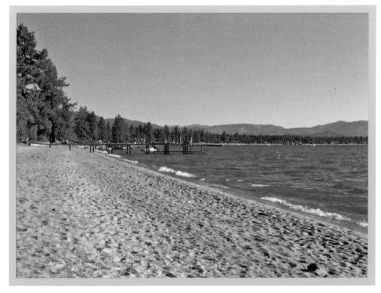

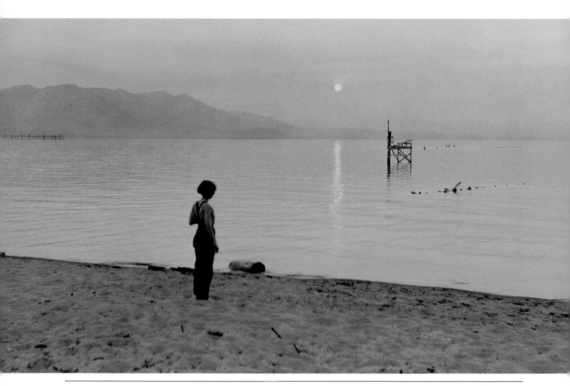

This is a sunset view on the Fourth of July in 1931 looking west, close to Camp Chonokis. Mabel Winter (later Whitney) and Ethel Pope established Camp Chonokis in 1927 as a summer and winter camp for girls aged 8 to 18. The camp consisted of a main lodge, a shower house, and tent cabins, and was situated on 20 acres about a half acre from the lake at Stateline. (Courtesy of Special Collections, University of Nevada, Reno; historical photograph C. W. Whitney.)

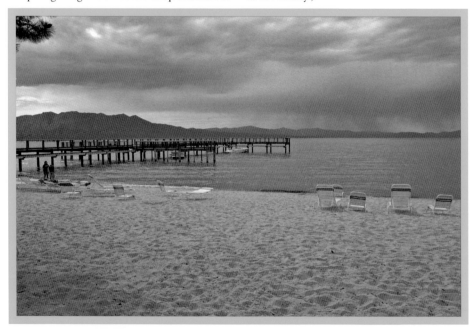

SHORELINES FROM STATELINE TO HOMEWOOD

Although this pier looks like the speedboat ride concession at Camp Richardson, it is actually Timber Cove Pier on the east shore of Lake Tahoe. After a devastating fire destroyed the pier in 1958, a new pier was built about 100 feet southwest of the original footings. Stories abound of people, after a liberating and easy divorce, throwing old wedding rings into Tahoe's waters. Divers are occasionally seen in this area searching for lost treasure. (Courtesy of Nevada Historical Society; historical photograph Walt Mulcahy, 1930s.)

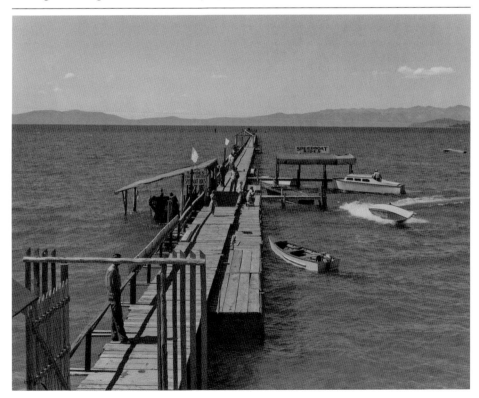

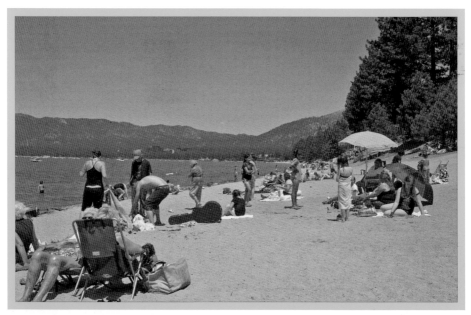

Lake Tahoe is essentially a wealthy enclave, and most of the shoreline is privately owned. Consequently, a public beach such as El Dorado Beach, located among a number of public beaches in South Lake Tahoe, is heavily visited during the summer months. This is the largest beach area in South Lake Tahoe and includes kayak and water-toy concessions, a swimming area, a picnic area, and a boat launch. (Courtesy of South Lake Tahoe Historical Society.)

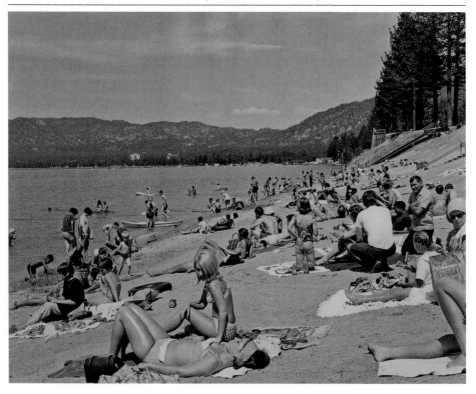

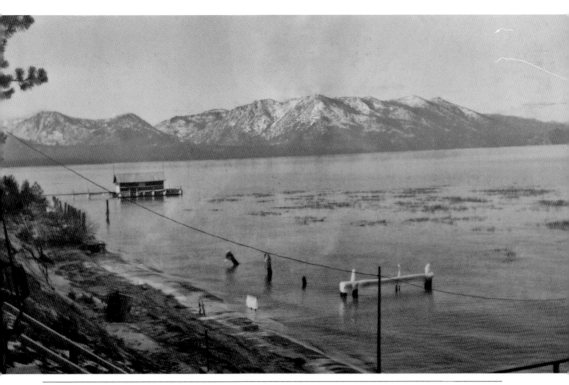

This is a view of a boathouse and pier to the immediate west of what is now Thomas Regan Memorial Beach. This is a popular area for Jet Skis, Canada geese, and recreationists of all sorts. The view was made from the intersection of Lakeview and Fresno Avenues. Historically, the Washo tribe gathered near this site, and during the 1950s, the community beach was one of the most popular throughout Lake Tahoe. (Courtesy of South Lake Tahoe Historical Society; Scott Hinton rephotograph.)

The steep bank was the shore of Eugene Lehe's property southwest of Thomas Regan Memorial Beach. The historical photograph, part of the 1916 shoreline survey, indicated that the lake level was at 6229.80 feet above sea level. In 1919, Lehe filed a suit against representatives of the U.S. Reclamation Service for damages from flooding of land and property bordering Lake Tahoe related to the damming of Lake Tahoe. (Courtesy of North Lake Tahoe Historical Society; Scott Hinton rephotograph.)

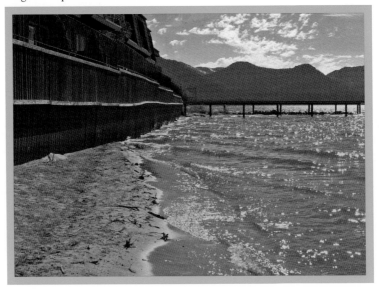

SHORELINES FROM STATELINE TO HOMEWOOD

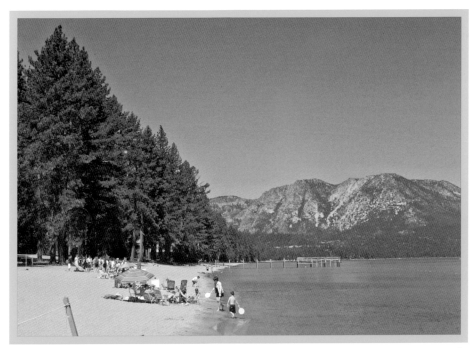

This view (shown below) of Jameson Beach includes the lodge, the dance pavilion at the water's edge, and the rebuilt pier. In 1923, Nellie Copeland, proprietor with her husband John of Copeland's Grove Hotel, competed with neighboring Tallac to the west by declaring that "the Grove" was a simple, homelike summer retreat for folks weary of the city. (Courtesy of South Lake Tahoe Historical Society; Megan Berner rephotograph.)

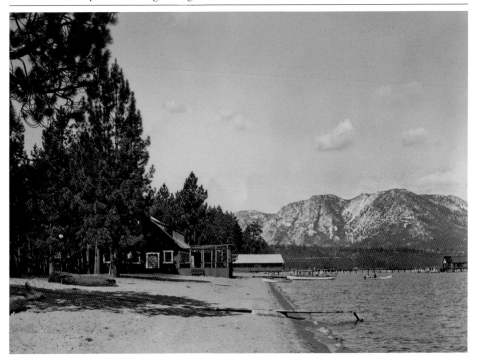

The 1913 photograph of Mount Tallac (9,785 feet above sea level) was made one year before the construction of the original Tallac House, which would have appeared in this view. Hikers and photographers have particularly enjoyed Mount Tallac, the sentinel for Lake Tahoe. Its fame derives in part from the cross of snow showing high on the northeastern slope in the spring and early summer. The name "Tellec" was a Washo word meaning either great mountain or large mountain. (Courtesy of North Lake Tahoe Historical Society.)

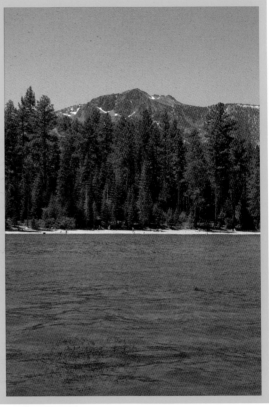

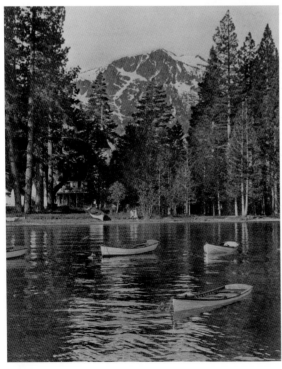

SHORELINES FROM STATELINE TO HOMEWOOD

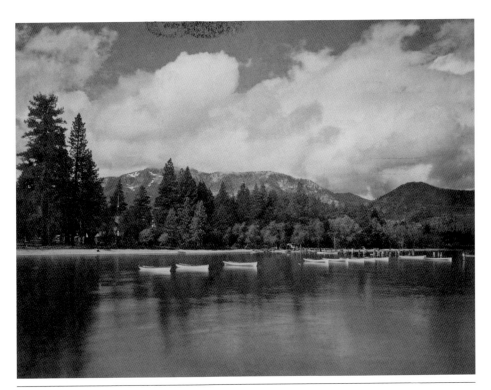

Many of the original accounts of Lake Tahoe derive from a lake view. This shot encompasses the Tallac Historic Site, land historically owned by three of the most affluent and socially elite families in the San Francisco Bay Area—the Baldwin, Pope, and Heller families. The cabins built near the Tallac site served as summer getaways. The structure with the steeple is the earlier version of the Tallac Hotel. (Courtesy of Nevada Historical Society.)

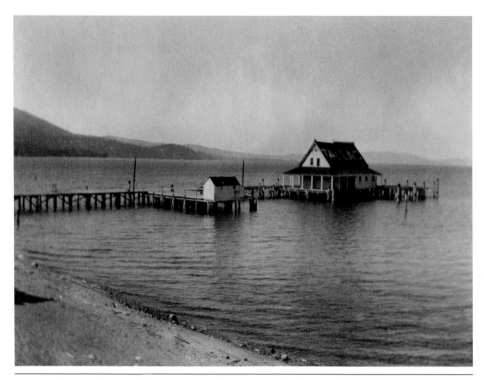

A pictorial remembrance of the pier at the Tallac Hotel reflects how the subject signifies what is important. The *San Francisco Alta* reported in July 1882, "Tallac is rustic and comfortable as well as commodious, with a white sand beach running one-half mile west, yet the only signs of civilization are the hotel and wharf, so carefully have the natural beauties of the grounds been preserved." (Courtesy of North Lake Tahoe Historical Society; Scott Hinton rephotograph.)

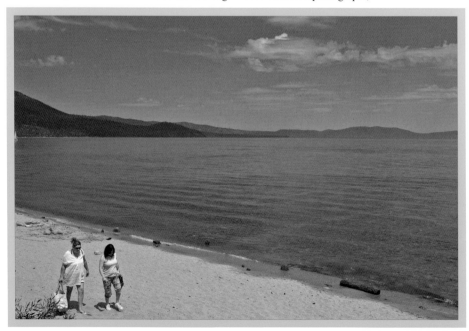

SHORELINES FROM STATELINE TO HOMEWOOD

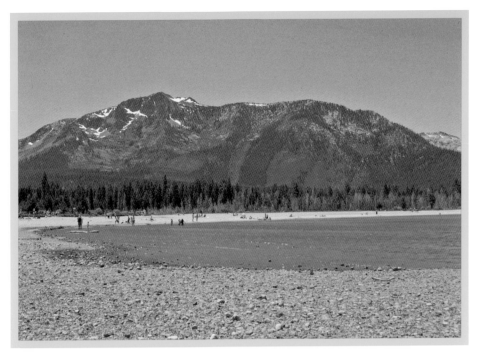

Baldwin Beach is a U.S. Forest Service recreational site located at the southern shore of Lake Tahoe near the Tallac Creek outlet. Baldwin Beach was named after Elias "Lucky" Baldwin, a Virginia City miner who owned 2,647 acres, including 1 mile of beach. Baldwin Beach was developed as a recreational site in 1955 and was opened to the public in 1956. (Courtesy of California State Library and *Stopping Time: A Rephotographic Survey of Lake Tahoe* by Peter Goin; Megan Berner rephotograph.)

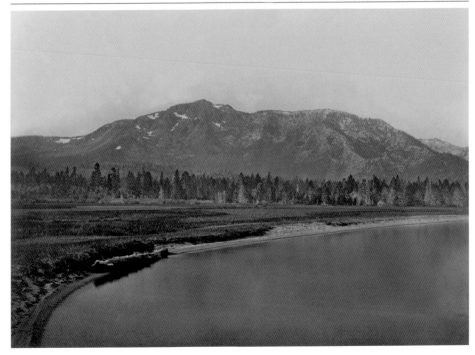

Historically, meadows throughout Lake Tahoe were subject to a variety of uses but principally for grazing cattle. This area along Baldwin Beach is off-limits because it is a nesting and riparian zone. This meadow reflects the beliefs of Elias "Lucky" Baldwin, who declared that the forests and groves within his property should never surrender to the woodsman's ax. The meadow reveals brilliant wildflowers such as the little elephant's head, lupine, cinquefoil, paintbrush, and Klamath flowers, among others. (Courtesy of Nevada Historical Society.)

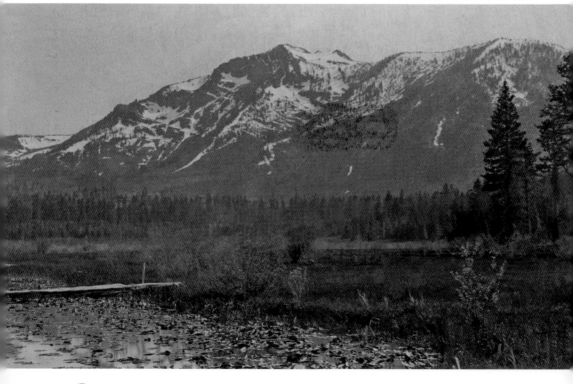

SHORELINES FROM STATELINE TO HOMEWOOD

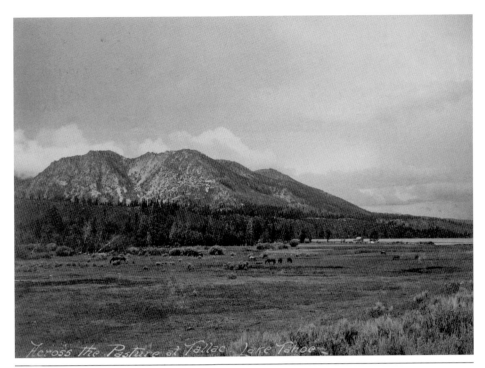

Across the Pasture at Tallac Lake Tahoe

This scene was marketed by the Alverson Studios at Lake Tahoe and featured Mount Tallac "across the pasture at Tallac Lake Tahoe," according to the original caption. This area is known today as Taylor Creek Marsh. The buildings in the far distance are the fish commission's old headquarters, a boathouse, and a wharf. There lake trout were caught using seines, large fishing nets that hang vertically in the water. The spawn were then reared in a hatchery. (Courtesy of Nevada Historical Society; Megan Berner rephotograph.)

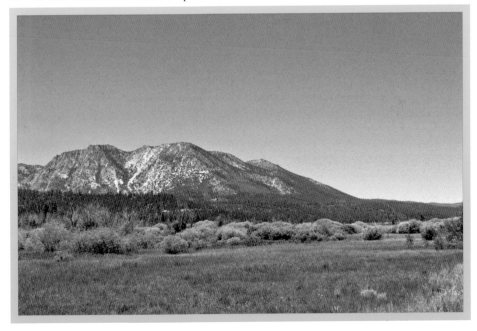

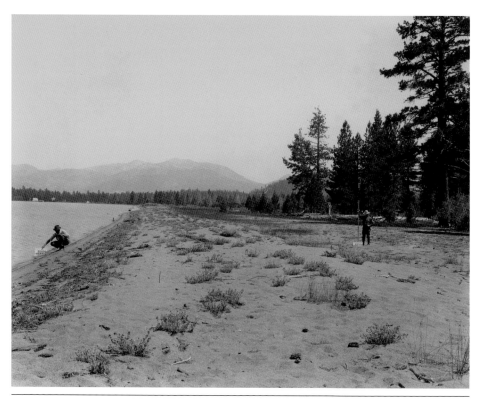

While subject to a 1916 lake-level survey, today this property is privately owned by the Ebright family. The Ebrights own more than 600 acres surrounding Cascade Lake. In 1882, Dr. Charles Brigham, a San Francisco surgeon, acquired a large acreage near Cascade Lake. Over the years, his holdings included Cascade, extended over the ridge to the southeast shore of Emerald Bay, Eagle Point, and south along Tahoe. (Courtesy of North Lake Tahoe Historical Society.)

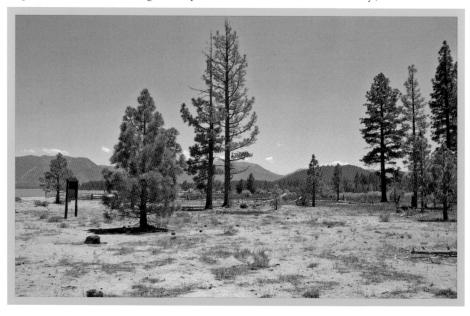

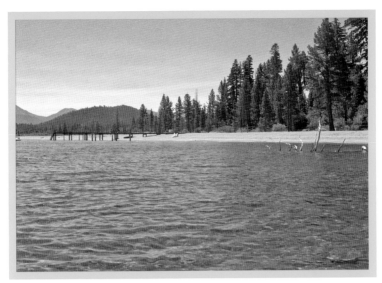

On a bluff overlooking Lake Tahoe, one-quarter mile west of the meadows, Dr. Charles Brigham, a prominent South Tahoe landowner and a proponent of cold-water swimming, built a large, one-story, four-bedroom summer home with a steamer landing and circular inside pilings for mooring small craft. This historical photograph has never before been published. It is from Brig and Mary Ebright's family album. This is the Brigham pier and boathouse around 1934. (Courtesy of Ebright family; Megan Berner rephotograph.)

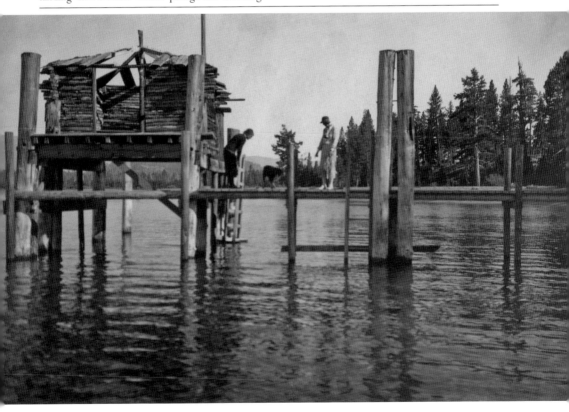

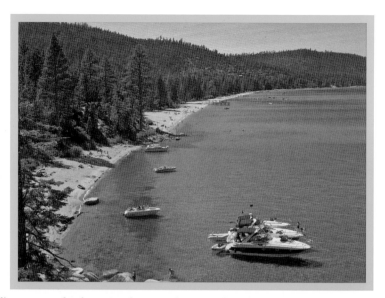

This bird's-eye view of Rubicon Beach was made from the steep rock promontory within D. L. Bliss State Park. The beach in the foreground is within the park, but beyond, the property is privately owned, marked with "No Trespassing" signs. The waters off Rubicon Point are among the deepest at Lake Tahoe, accounting for the water's rich blue color. The historical legend of Julius Caesar's crossing the Rubicon prompted the naming of this area. (Courtesy of Special Collections, University of Nevada, Reno.)

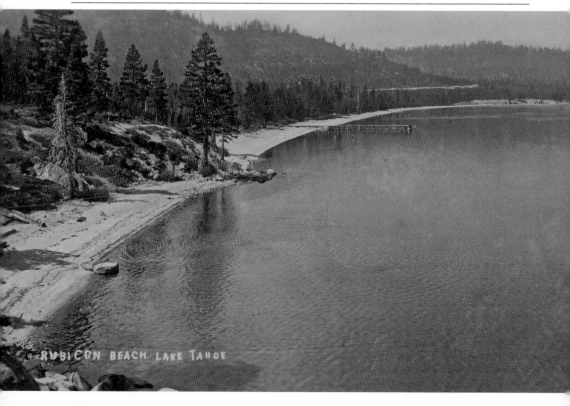

RUBICON BEACH LAKE TAHOE

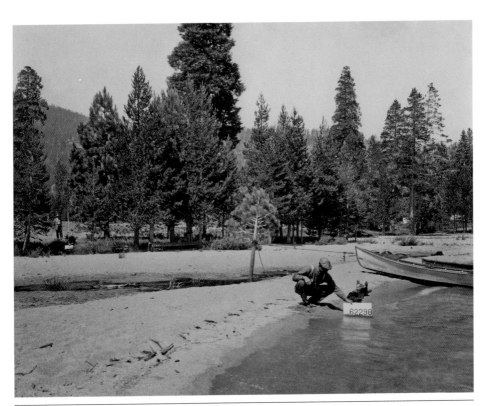

Josephine Frost and her husband, Horatio Harper, an oil-company executive, assumed control of her father's Rubicon Park tract in 1905. This operation included a modest, two-and-a-half–story hotel, several cottages, tents, corrals, a storehouse, a barn, and a stable. The facilities included a launch, 10 fishing skiffs, furniture, two pianos, machinery, and livestock on 1,100 acres bordering Rubicon Bay. Dairy Creek's outlet is pictured in both photographs. (Courtesy of North Lake Tahoe Historical Society.)

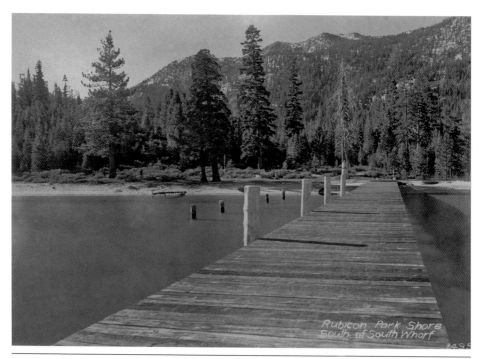

Rubicon Park shore, south of South Wharf, is the site of Rubicon Park Lodge. In 1887, Amos L. Frost owned 630 acres, including a portion of Rubicon Bay, and by 1889, he established A. L. Frost's Rubicon Park Tract, which provided a summer campground devoted to serving outdoorsmen. By 1900, it had been developed into the Rubicon Park Lodge, and by 1915, the resort was gone, although some buildings still remained into the 1920s. (Courtesy of Special Collections, University of Nevada, Reno.)

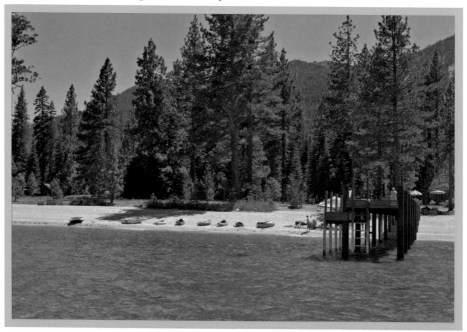

SHORELINES FROM STATELINE TO HOMEWOOD

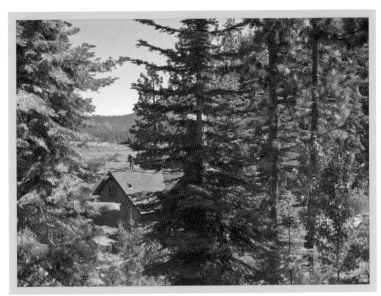

Overlooking the southern portion of Rubicon Bay, this pair of photographs illustrates how lake views have changed since 1970. Also this estimate of a rephotographic site from Meeks Bay Avenue indicates the density of housing and second- and third-growth forests on private property. The heyday of Rubicon mansions and resorts passed long ago, especially after the breakup of the 350-acre Newhall estate. Today most of the property and access to it is privately controlled. (Courtesy of Nevada Historical Society.)

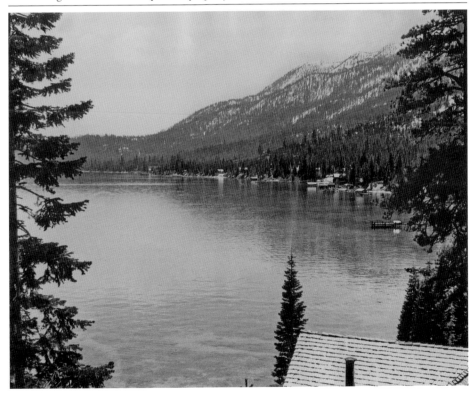

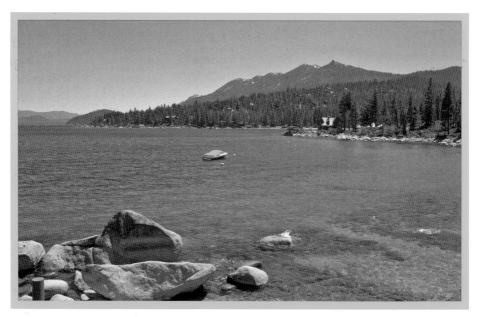

The historical photograph by R. J. Waters was taken between 1867 and 1880. Meeks Bay has had a plethora of names over the years, including Micks, Meigs, Meegs, and Buttermilk Bay. The Washo summered near its beaches. During Tahoe's industrial era, Meeks Bay was severely logged, such that volumes of sawdust, bark, and pine-branch cuttings littered the shoreline. The contemporary view is from private property off Drum Road. (Courtesy of North Lake Tahoe Historical Society.)

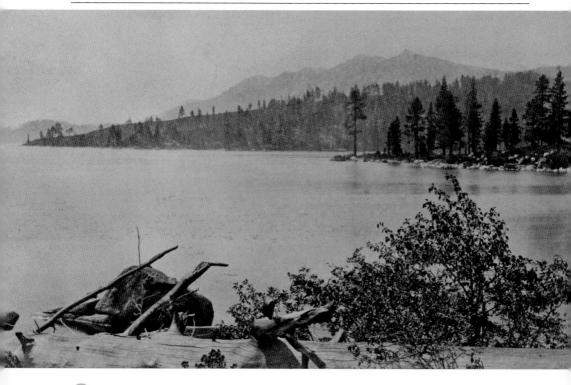

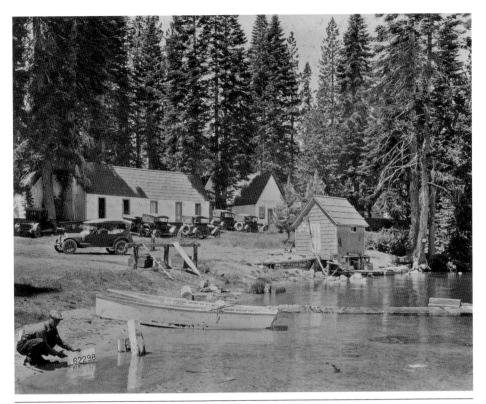

McKinney's Resort was a regular stop for Lake Tahoe's spectacular steamers, including the *Governor Stanford* and the *Tahoe*. John McKinney owned a ranch at the summit of Burton's Pass but moved into the Tahoe basin in 1862. The south side of Upson Bay, now McKinney's, offered sheltered beach frontage, plenty of running water from McKinney's Creek, an abundance of game, and dense timber. In 1863, McKinney established the Hunter's Retreat at the site. (Courtesy of North Lake Tahoe Historical Society.)

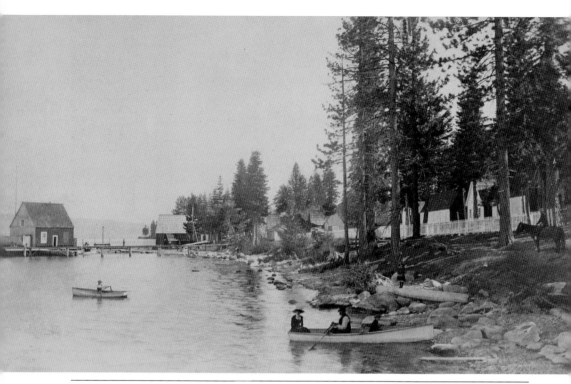

Chambers Landing, previously McKinney's Landing, is allegedly the only remaining bar where patrons can drink alcohol while resting over Tahoe's water. By 1889, McKinney's was listed as one of the principal resorts at Lake Tahoe, with a post office, barbershop, and waterfront saloon. In 1920, David Chambers, formerly the manager of Brockway Hot Springs, purchased the hotel, cottages, and surrounding land, and renamed the resort Chamber's Lodge. (Courtesy of Special Collections, University of Nevada, Reno.)

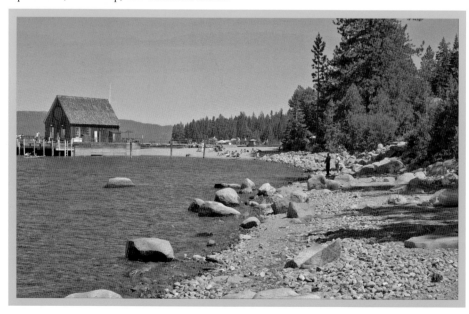

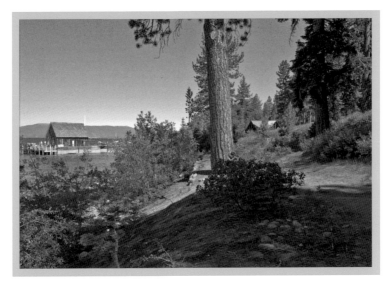

This 1909 photograph (below) of McKinney's Landing from the Putnam and Valentine album of Lake Tahoe includes the resort's cabins at right. Twenty tourist cabins and numerous tents were available for rent, but surprisingly many of the guests preferred the free, rugged outdoor accommodations, where they slept wrapped in bedrolls under the canopy of trees. John Muir, a regular guest at McKinney's, wrote eloquently about the stately sugar pines standing like priests in benediction over a congregation. (Courtesy of Nevada Historical Society.)

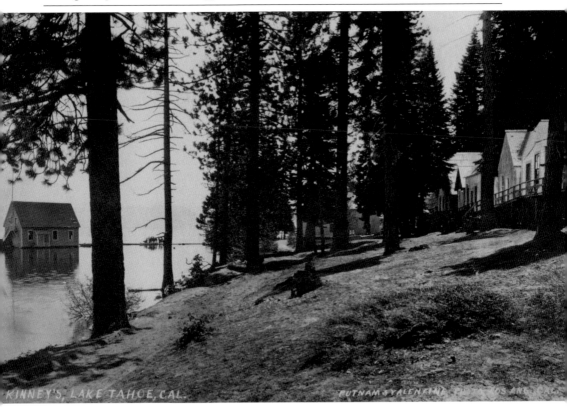

KINNEY'S, LAKE TAHOE, CAL. PUTNAM & VALENTINE

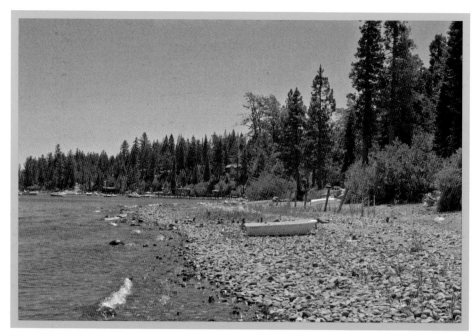

The pre-1900 boathouse at McKinney's Landing was turned into a dance floor for McKinney's lodge guests. The photographer was standing on McKinney's pier in front of the old Glenbrook House that, during the summer of 1897, had been moved across the lake on a 104-foot-long cordwood barge. After renovation, the house became the hotel and social hall. The historical photograph is part of the 1916 shoreline survey. (Courtesy of North Lake Tahoe Historical Society.)

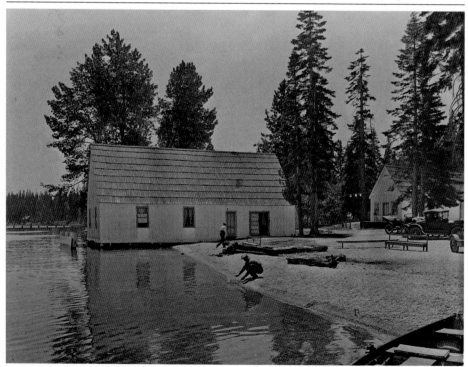

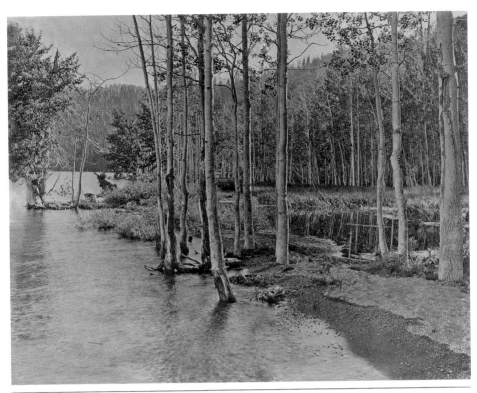

Aspens and swampy land punctuate the west shore near Tahoe Pines, an area previously known as Idlewild until the post office was established in 1912. Tom McConnell, from Sacramento, built a lake house that was considered a resort by many visitors (even though it was not) because it had picnic grounds, a dance floor under the pines, summer cottages, and a steamer wharf. For nearly 25 years, Idlewild symbolized the height of social activity at Lake Tahoe. (Courtesy of North Lake Tahoe Historical Society.)

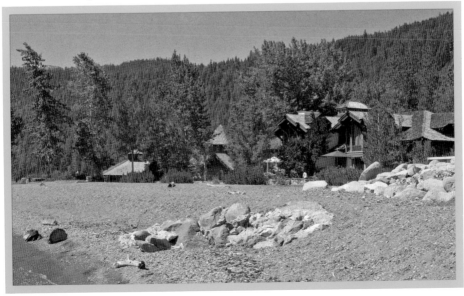

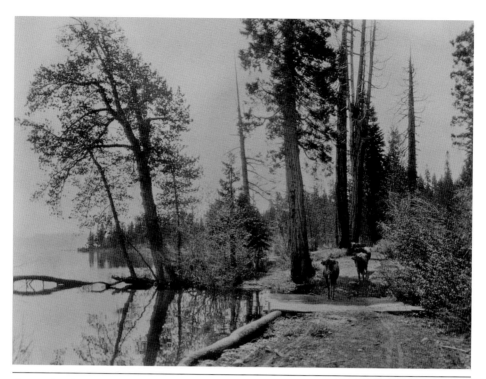

Once a bucolic trail and rustic pine-log bridge for dairy cattle, this trail is now simply the outlet of Quail Creek, directly next to Highway 89. In the summer of 2009, when the rephotograph was taken, Lake Tahoe's water level was low in part due to three-plus years of below-average precipitation. McKinney's Landing clubhouse and pier on McKinney Point (now Chamber's Landing) is at the far left. Quail Lake is a reservoir 1 mile up the canyon. (Courtesy of Nevada Historical Society.)

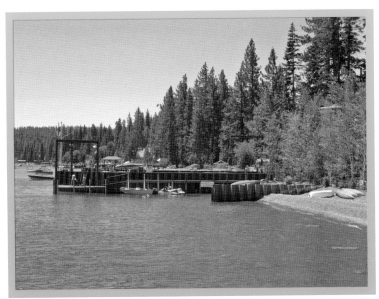

The Homewood Resort was decorated with Chinese lanterns during the summer of 1916. This clubhouse, an entertainment center for Arthur and Annie Jost's guests, had a dormered roof, an open porch, and cedar sidings. Prior to the 1880s, the Homewood Resort did not exist. Early settlers had moved on from the area to more lucrative natural environments. On July 31, 1909, a post office was established there. The Josts' resort opened the following year. (Courtesy of North Lake Tahoe Historical Society.)

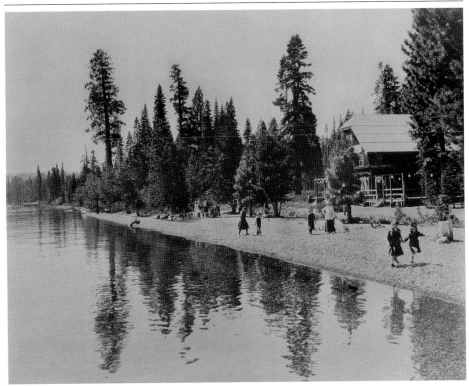

The Homewood Pier, a historical site of varied recreational activities, today fronts the West Shore Café and Inn. The pier's length and water levels affect the comparative views. Behind the café, recreationists enjoy the Homewood Mountain Ski Resort, which boasts spectacular winter views of the lake. The ski resort is the only one on the west shore. Jake Obexer's marine pier is just to the south. (Courtesy of Special Collections, University of Nevada, Reno.)

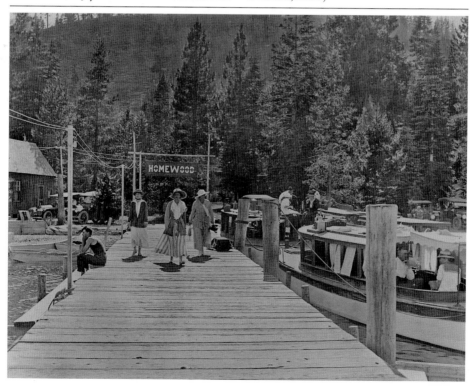

SHORELINES FROM STATELINE TO HOMEWOOD

CHAPTER 5

ANGORA, CASCADE, ECHO, FALLEN LEAF, AND FLOATING ISLAND

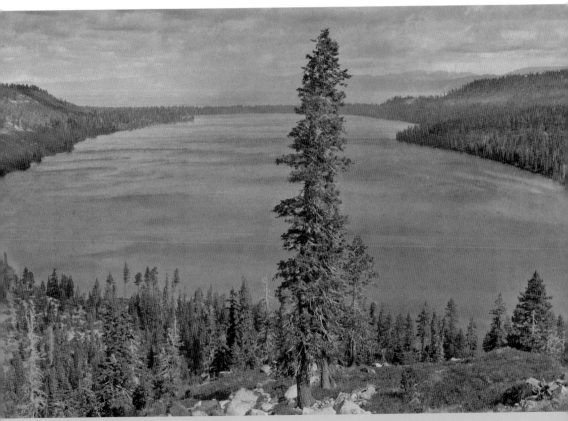

Glaciers flowing down the Glen Alpine Valley created Fallen Leaf Lake approximately 100 feet above Lake Tahoe. The lake is surrounded by Cathedral Peak and Mount Tallac to the west and Angora Ridge to the east. It takes eight years, on average, to cycle entirely new water in the lake. This is extremely fast compared to Lake Tahoe's 700 years. Fallen Leaf Lake is also featured in numerous movies, including *The Bodyguard*. (Courtesy of Nevada Historical Society.)

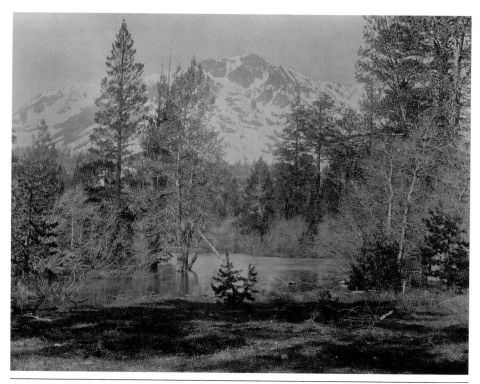

Fallen Leaf Lake became a popular area as early as 1906 when Mr. and Mrs. William Price established a resort and campground there. William Price was a Stanford graduate educated as a naturalist, and his efforts, combined with others of the Nature Guide movement of 1926–1927, promoted an appreciation of the biology and natural history of the Tahoe environment. In many ways, Fallen Leaf Lake is a microcosm of Lake Tahoe. (Courtesy of Nevada Historical Society.)

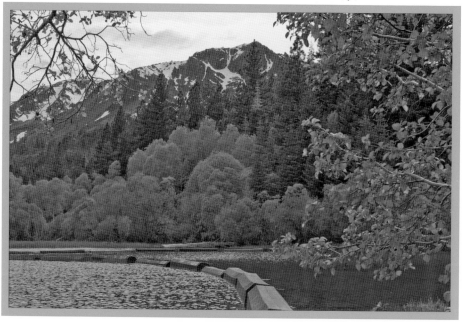

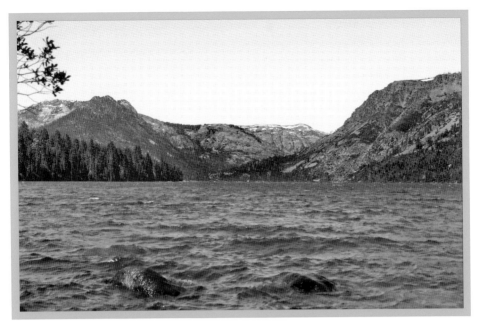

Fallen Leaf Lake was presumably named after the Delaware chief Falling Leaf, who served as a guide for a Tahoe-Sierra exploring party in the late 1840s. There are other origin stories indicating that the precise etymology of the lake's name may never be known. Historically the fishing here has been excellent. The sole outflow of Fallen Leaf Lake is through Taylor Creek, one of the major tributaries to Lake Tahoe. (Courtesy of Nevada Historical Society; Megan Berner rephotograph.)

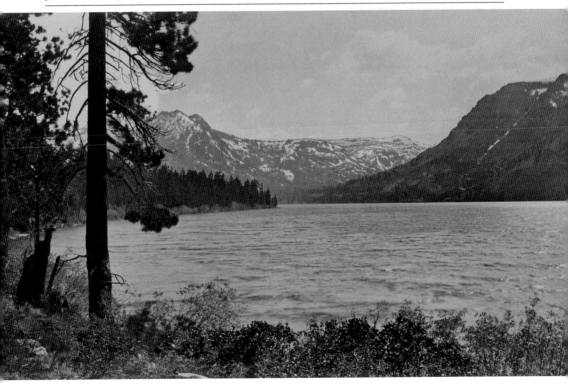

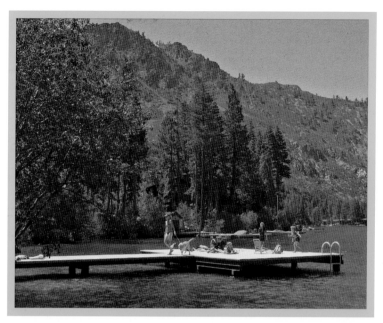

The southern tip of Fallen Leaf Lake is a secluded resort area with private homes and cabins nestled in the forests. Because of the steepness of the terrain, most of the residences are on the southeastern shores. This dock is on private property next to Stanford Camp. Glen Alpine Creek is beyond the dock to the west. (Courtesy of Nevada Historical Society; Scott Hinton rephotograph.)

ANGORA, CASCADE, ECHO, FALLEN LEAF, AND FLOATING ISLAND

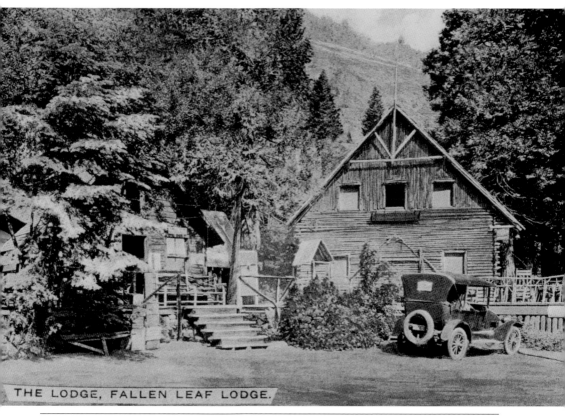

THE LODGE, FALLEN LEAF LODGE.

In 1953, the alumni association of Stanford University began using the Fallen Leaf Lodge area east of Glen Alpine Creek as a location for summer camps. Six years later, the alumni association purchased the land and established the Stanford Sierra Camp for recreational use. In 1962, the fee for one week was $65. The camp was slightly remodeled in 1969 to meet new environmental codes for water and sewer management. (Courtesy of Nevada Historical Society; Megan Berner rephotograph.)

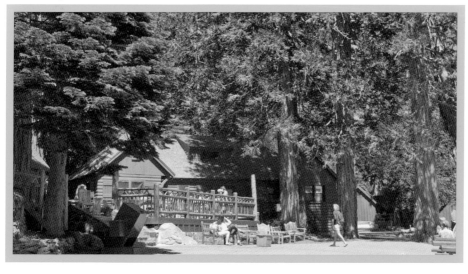

ANGORA, CASCADE, ECHO, FALLEN LEAF, AND FLOATING ISLAND

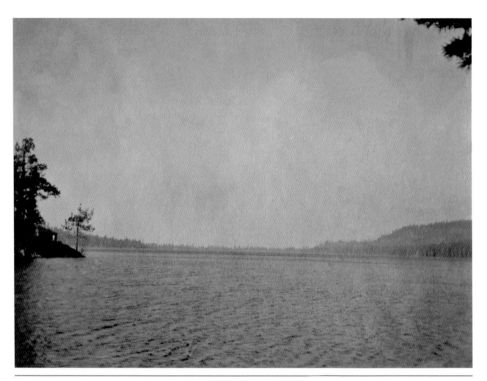

Scenic views are common throughout the Lake Tahoe area. This view (shown above) of lake and sky was made near the Stanford Camp at the end of Fallen Leaf Road. In 1998, the Stanford Alumni Association merged with the university and changed the name from the Stanford Sierra Camp to the Stanford Alumni Association Sierra Programs. Stanford students run a summer family camp program. Goals include creating programs for work, play, friendship, and community. (Courtesy of Nevada Historical Society; Scott Hinton rephotograph.)

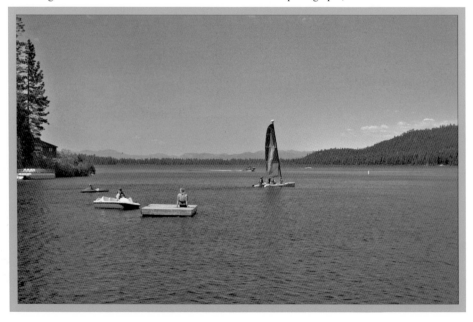

ANGORA, CASCADE, ECHO, FALLEN LEAF, AND FLOATING ISLAND

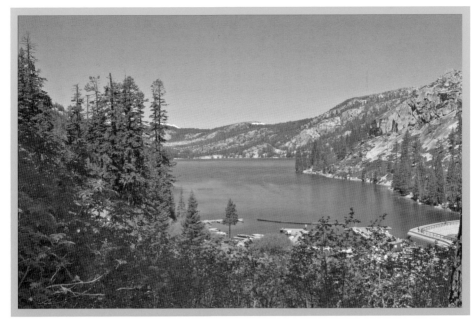

John Kirk of Placerville developed Echo and Aloha Lakes in the 1870s by running water from Echo Lake to the South Fork of the American River. In the spring thaw of 1911, the dam broke, and 2,000 acre-feet of water washed Osgood's Toll House from its foundation at the foot of Meyers Grade. In 1920, the Echo Lake dam was raised, joining the two lakes. The lodge burned in 1939. (Courtesy of South Lake Tahoe Historical Society; Scott Hinton rephotograph.)

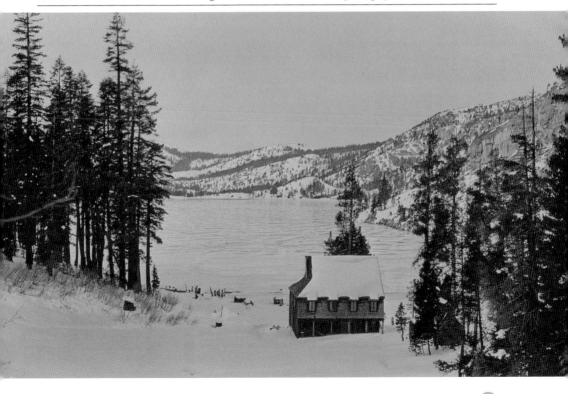

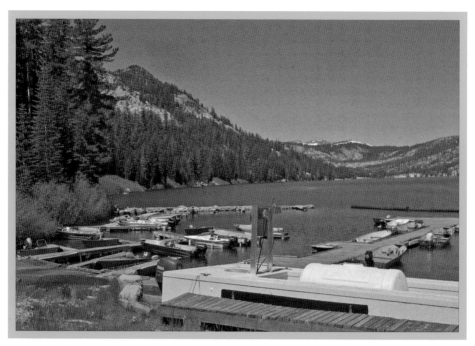

Known for its fishing since the 1870s, Echo Lake is the southeastern link in a chain of glacial lakes, including Fallen Leaf, Cascade, Aloha, Tamarack, Lake of the Woods, and numerous others in the Desolation Valley. Upper and Lower Echo Lakes are gateways to the High Sierra wilderness backcountry. The marina serves notice of the popularity of the Echo Lakes. There are 139 cabins on leased U.S. Forest Service land and another 22 on private land. (Courtesy of South Lake Tahoe Historical Society.)

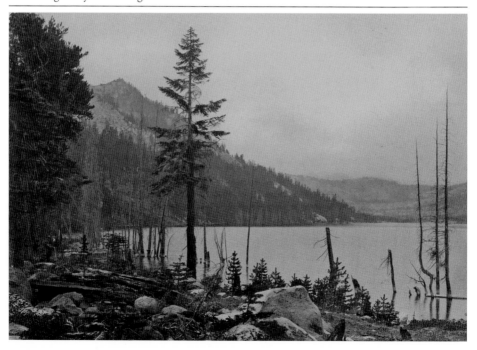

ANGORA, CASCADE, ECHO, FALLEN LEAF, AND FLOATING ISLAND

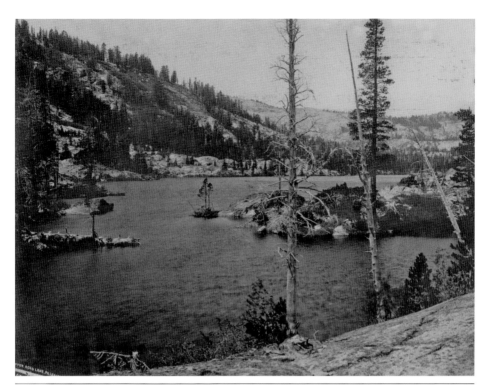

The dam on Lower Echo Lake stores 6 feet of surface water (approximately 1,800 acre-feet) that is owned and managed for commercial purposes. From the earliest days of Sierra settlement, hardy individuals such as Jack Butler, Hamden Cagwin, and Maurice McLoughlin, as well as the Caldwell family, built cabins in the area. These photographs were taken with the connecting channel just to the left behind the view. Cabins pepper this spectacular alpine and granite landscape. (Courtesy of North Lake Tahoe Historical Society.)

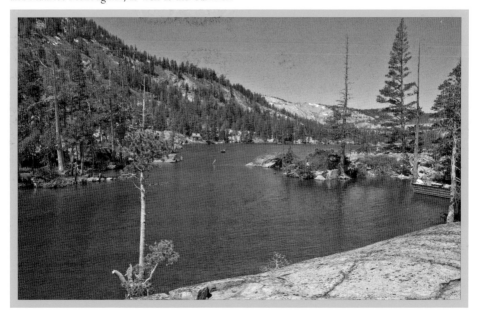

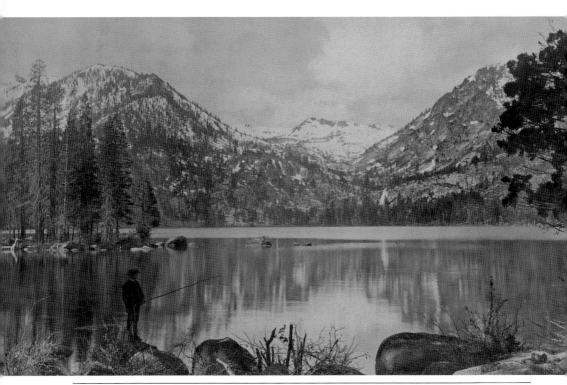

Many well-known figures visited Cascade Lake, including John Muir, Mark Twain, and a governor of Nevada who serenaded Dr. Charles Brigham with a brass band. While most of the property surrounding Cascade is owned by the Ebright family, a few small parcels that front the north end of the lake were sold to private individuals. The rephotograph was made from the backyard of Stewart Abercrombie's property. (Courtesy of Special Collections, University of Nevada, Reno; Megan Berner rephotograph.)

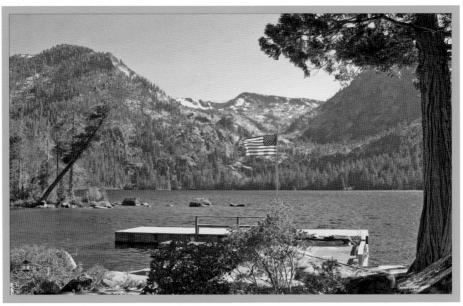

ANGORA, CASCADE, ECHO, FALLEN LEAF, AND FLOATING ISLAND

As a testimony to the concept of nature photography, the photograph below is a view of Maggies Peaks (Fleetfoot Peak) and Cascade Creek directly below Cascade Lake. The measured land from Cascade Lake to Lake Tahoe, approximately 600 acres excepting five 1-acre parcels, is deeded land and not leased, as previously indicated in the public record. Cascade Lake is approximately 300 feet above Lake Tahoe. (Courtesy of Ebright family.)

Jimmy Walker, an entertaining Tahoe character, lived a hermit's life in a small cabin near where Cascade Creek empties into Lake Tahoe. He lived alone in the cabin year-round for 11 years but was known as an excellent seafood chef. Today the creek adjoins expensive and secluded private property at the terminus of Cascade Road. The tree is the same in both views. The historical photograph was made during the 1930s. (Courtesy of Ebright family)

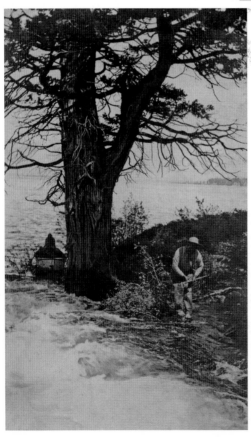

ANGORA, CASCADE, ECHO, FALLEN LEAF, AND FLOATING ISLAND

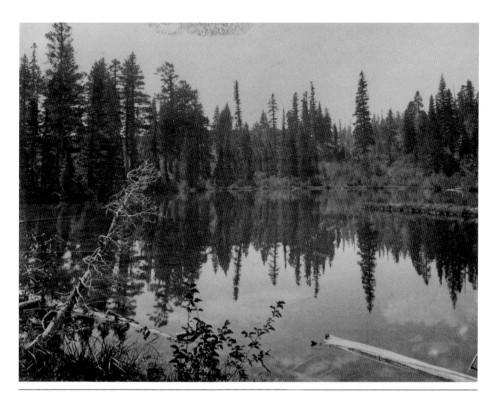

In 1890, this unique lake had a 20-foot-diameter floating mat of grass and shrubs that could be moved with oars or poles. It is a mystery why mats slough off at this 5-acre lake and not at any other, for in all other respects this lake seems ordinary. Since a dense stand of conifers rings this lake, fire is an imminent danger. Therefore, camping is prohibited. Floating Island Lake is along a popular wilderness hiking trail that leads to Cathedral Lake and Mount Tallac. (Courtesy of North Lake Tahoe Historical Society.)

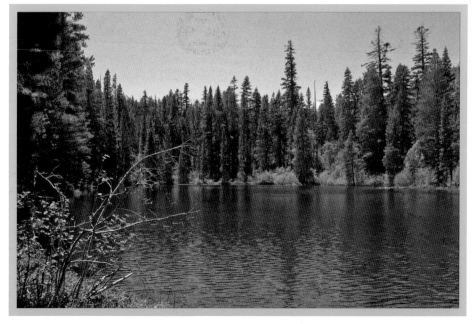

Lower Glen Alpine Falls were also known as Big Falls and Fallen Leaf Falls. The falls are more than 60-feet high, easily accessible, and a popular place for small weddings. Glen Alpine Creek is the primary source of water for Fallen Leaf Lake. Upper Glen Alpine Falls was previously named Modjeska Falls after an actress of Polish origin who appeared in Virginia City during the Comstock era. (Courtesy of Special Collections, University of Nevada, Reno.)

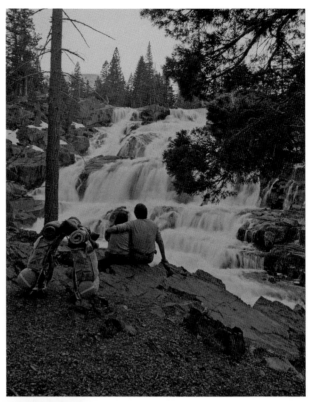

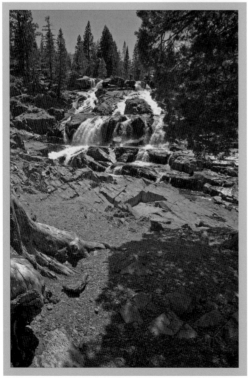

ANGORA, CASCADE, ECHO, FALLEN LEAF, AND FLOATING ISLAND

CHAPTER

6

EXCURSIONS

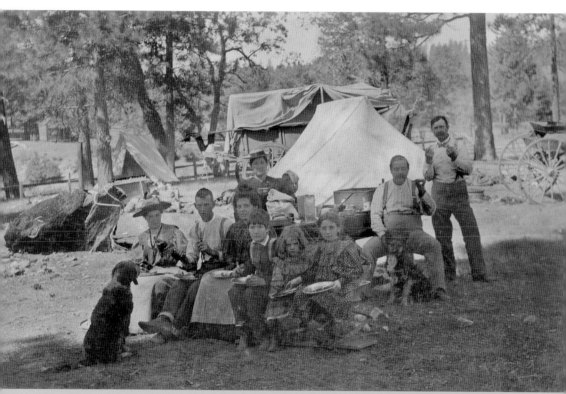

The early 20th century established various methods for the consumption of nature. Romanticism launched nature tourism in national parks and scenic areas such as Lake Tahoe. The rise of leisure time and evolving modernity provided the tools and materials that made the camping experience possible. This *c.* 1898 photograph portrays a group of campers with food. Pictured are Grace Crosett, Laura Switherbank, and the Taylor family, including Maurice, Amy, Era, Tom, Alice, and Ernest. (Courtesy of South Lake Tahoe Historical Society.)

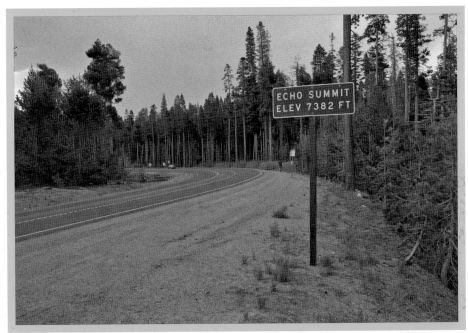

The old Meyers Grade, known as the Johnson Pass cut off, included a series of switchbacks and deep cliffs along the roadway. In 1855, the California legislature passed the Wagon Road Act that funded the construction of a wagon road from Sacramento to Nevada; this is now U.S. 50. Echo Summit is the apex of Meyers Grade, which is named after George Henry Dudley Meyers, a native of Germany and the owner of Yank's Station in Lake Valley. (Courtesy of South Lake Tahoe Historical Society.)

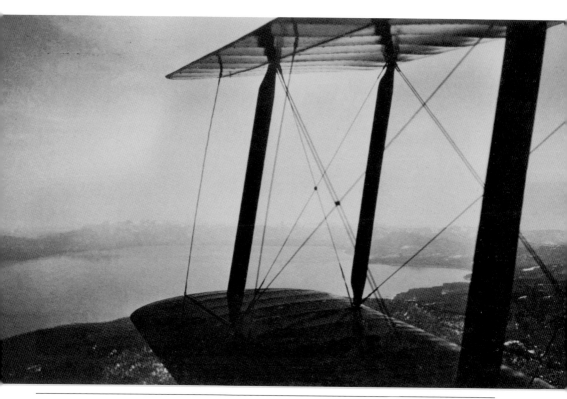

This general view of South Lake Tahoe from a biplane was made early in aviation history. From 1914 to 1925, almost all aircraft were biplanes. The first type of biplane was called a pusher biplane because the motor was mounted behind the wing and the prop pushed the airplane forward. The contemporary view was taken from Rob Lober's Rans S6 Blue Coyote, an experimental small craft with pontoons mounted under the fuselage. (Courtesy of Nevada Historical Society.)

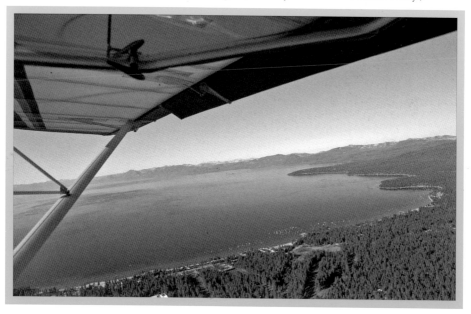

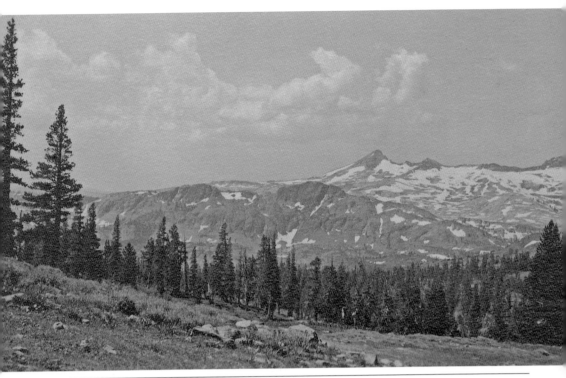

South Lake Tahoe is characterized by its grand vistas and spectacular hiking. Pyramid Peak (9,957 feet above sea level) was a landmark for emigrant and exploratory parties in the 1840s and 1850s. Pyramid Peak overlooks Devil's Basin in Desolation Valley. Apparently, William Brewer of the Whitney Survey first climbed the peak on August 20, 1863. The above photograph was made above Gilmore Lake off the trail from Glen Alpine to Tallac. (Courtesy of Special Collections, University of Nevada, Reno; Megan Berner rephotograph.)

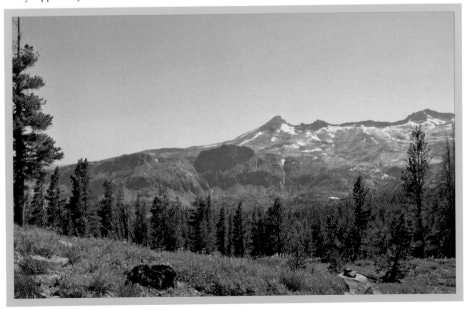

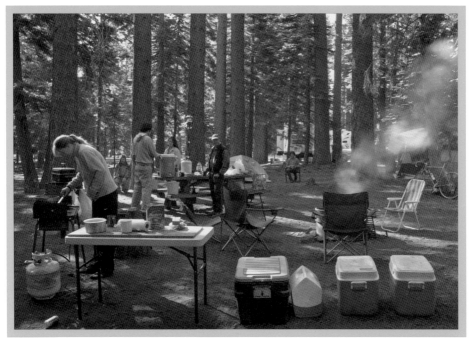

One of the most popular campgrounds throughout Lake Tahoe is at Fallen Leaf Lake. Nestled among towering native pine trees, the campground today offers a variety of recreational activities and is close to the Taylor Creek Visitor center. This is a national forest campground operated by a private concessionaire. This is the site of the rephotographic team field camp. Participants are preparing breakfast before seeking out additional sites. (Courtesy of South Lake Tahoe Historical Society; Scott Hinton rephotograph.)

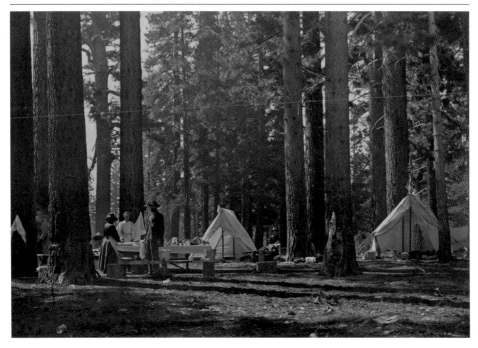

www.arcadiapublishing.com

MAP SEARCH

Discover books about the town where you grew up, the cities where your friends and families live, the town where your parents met, or even that retirement spot you've been dreaming about. Our Web site provides history lovers with exclusive deals, advanced notification about new titles, e-mail alerts of author events, and much more.

MADE IN THE USA

Arcadia Publishing, the leading local history publisher in the United States, is committed to making history accessible and meaningful through publishing books that celebrate and preserve the heritage of America's people and places. Consistent with our mission to preserve history on a local level, this book was printed in South Carolina on American-made paper and manufactured entirely in the United States.

This book carries the accredited Forest Stewardship Council (FSC) label and is printed on 100 percent FSC-certified paper. Products carrying the FSC label are independently certified to assure consumers that they come from forests that are managed to meet the social, economic, and ecological needs of present and future generations.

FSC
Mixed Sources
Product group from well-managed forests and other controlled sources

Cert no. SW-COC-001530
www.fsc.org
© 1996 Forest Stewardship Council

Find Your Place in History.